T0287151

CHESHIRE
MURDERS AND
MISDEMEANOURS

PAUL & ROSE HURLEY

AMBERLEY

First published 2023

Amberley Publishing
The Hill, Stroud
Gloucestershire, GL5 4EP

www.amberley-books.com

British Library Cataloguing in Publication Data.
A catalogue record for this book is available from the British Library.

ISBN 978 1 3981 1124 0 (paperback)
ISBN 978 1 3981 1125 7 (ebook)

Typesetting by SJmagic DESIGN SERVICES, India.
Printed in Great Britain.

CONTENTS

INTRODUCTION

In 1974, the local government was reorganised. Before that, the county of Cheshire included many towns. Within the old boundaries the Wirral, Stockport, Dukinfield, Hyde and Romiley could be found, to name just a few. The River Mersey formed a natural border in the north. Old Cheshire did not include Warrington or Widnes – both were in Lancashire. This book will cover the whole of the original Cheshire boundary.

Before going further, let's look at the agencies mentioned in the following stories who upheld law and order in the county. The Cheshire Constabulary came into force under the Cheshire Constabulary Act in 1829 and was amended in 1852 to serve the constabulary. There was a police headquarters at No. 4 Seller Street, Chester.

In 1856, the County and Borough Police Act was introduced, and the Cheshire Constabulary was abolished and a new one was formed. This Act was seen as providing counties with a reputable police force. The first full Cheshire Police

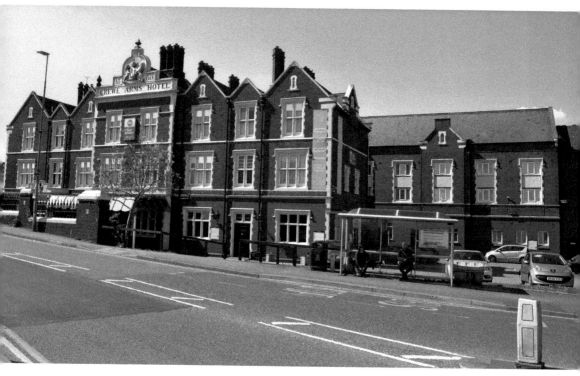

Crewe Arms Hotel.

Committee met at the Crewe Arms Hotel on 3 February 1857, with the force being formally inaugurated on 28 April that year. In 1883, Sandiway architect John Douglas was tasked with building a purpose-built police headquarters, which he did at No. 142 Foregate Street, Chester – the building still stands but is no longer a police HQ. Under the County and Borough Act there were separate borough police forces within Cheshire for the bigger towns such as Macclesfield, Birkenhead and Stockport, all with their own chief constables and administration. This HQ lasted until the new one was built opposite the castle in 1967. The present one was built in Winsford in 2004.

Through the 1800s and into the last century the central court was Chester Assize Court in Chester. It is still there today but is now called Chester Crown Court. Every area of the county had its own police division, usually with a superintendent in charge. The main prisons in Cheshire during the 1800s were Chester Castle Gaol and later Knutsford Prison. Then there was Northgate Gaol and later Chester City Gaol, House of Correction and Bridewell, which opened in 1808 and closed in 1872. The present Northgate is a shadow of its former self. The historian Hemmingway described the enormous gateway as 'an

Police headquarters, No. 142 Foregate Street.

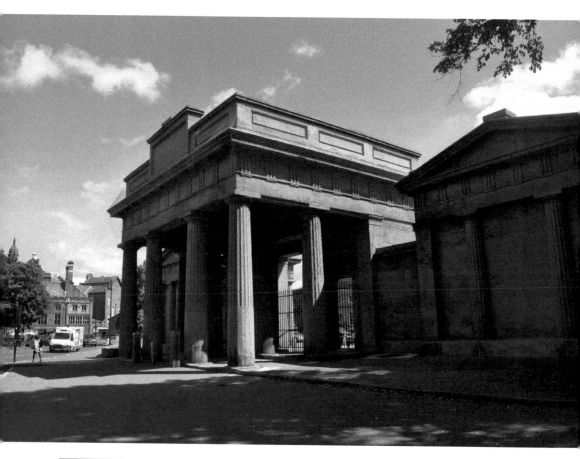

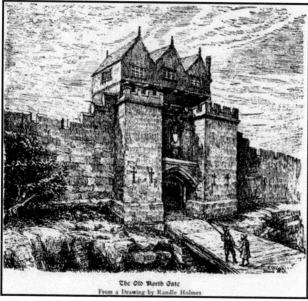

Above: Chester Assize Court entrance.

Left: Drawing of Northgate Gaol by Randle Holmes.

inconvenient and unseemly pile of buildings'. Although resting upon sandstone, it had dungeons that were cut into it, forming dank and dreary cells.

Some of the prisoners locked up there were unlikely to walk free again. Described in the seventeenth century as being a 'dark, stinking place with a dead man's room', it was not a very nice ending to a life. Here, prisoners from all over Cheshire were kept before execution, having been condemned to death. Torture was also carried out there. In fact, one of the cells was so small it was torturing to even be in it, hence its name 'Little Ease'. Public flogging and transportation to Australia and the Americas were alternative punishments for the 'luckier' prisoners. Still seen through the railings at the side of the gate and above the canal is the Bridge of Sighs – another Grade II listed building. It was named as such because it was a footbridge built around 1793 and designed by the architect Joseph Turner that led across the canal from the Northgate Gaol to the Little St John Chapel in the Bluecoat School. It was here that the prisoner could be entertained in a 'special room'. They were to receive the last rites before being returned to the gaol to meet the executioner and, in the terminology of the day, be 'Turned Off', meaning to be executed by hanging. When built, this narrow and flimsy-looking bridge had high railings to prevent the prisoners from attempting to pre-empt the executioner.

Bluecoat School/St John's Hospital.

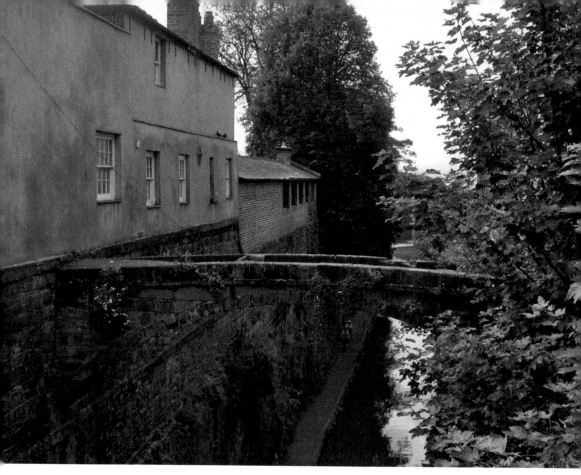

Bridge of Sighs.

Up until 1801 all executions took place at Gallows Hill in Boughton – this hill is still there but is now called Barrel Well Hill. The last felons to be hanged were Thompson, Morgan, and Clare, who were 'Turned Off' for forgery. After that date, felons were sent to Northgate Gaol to be hanged. Later, the City Gaol built at the rear took on the onerous task of carrying out the death sentence. Public executions were stopped in 1868. The City Gaol ceased to be a gaol in 1871. Before that, in 1866, the duties of the county were transferred to Knutsford Prison, where the death sentence was carried out until 1912. In 1810, the present Northgate was designed by Thomas Harrison to replace the old gaol and gate. This is now a Grade I listed building.

The Murder Act of 1752 stated hanged felons could not be buried. Their bodies were to be hung in chains and later dissected – sometimes in public. This was seen as an extra posthumous punishment, but also to try and deter body snatchers. This was a very lucrative, if sordid, occupation where new graves were opened and the bodies were taken away to sell to hospitals for training purposes. It was the only way that such exhibits could be obtained. Then came the Anatomy Act of 1832 – again, to try and deter body snatchers. It demanded that dead bodies were to be dissected many times in public. Severe punishments

The replacement Northgate.

open to the courts included being hanged, drawn, and quartered. This practice was carried out in public and was treated as something akin to a social gathering, with stalls and food sellers – a festive occasion. The prisoner was hanged but cut down before death; on some occasions, their private parts were cut off and burned in front of them. The intestines were removed and burned (again, when they were still alive), and the body was chopped into four sections before being displayed in public.

Cheshire's main prison during Victorian times was the custom-built Knutsford Prison. It was a large prison opened in 1818 in the centre of the town, then known as Nether Knutsford. The building included a sessions house, grand jury room and house of correction. Before this, John Howard illustrated the hotchpotch methods of detaining felons when he published *The State of the Prisons* in 1777. This had some bearing on how prisoners were dealt with and improved conditions. One treatment, called the Treadmill, had prisoners walk up a moving staircase or turn a heavy crank – it did nothing but exert and punish them. Floggings and moving cannonballs from one side of the yard to the other were punishments. John Howard died in Ukraine in 1790, leaving us with the organisation that still exists today as the Howard League of Penal Reform.

Public hangings, however, stopped in 1868 with the Capital Punishment Amendment Act. The last person to be hanged in public was an Irish Republican,

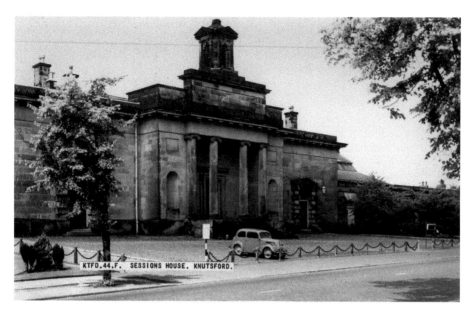

KTFD.44.F. SESSIONS HOUSE. KNUTSFORD.

Sessions house and gaol, Knutsford.

Michael Barrett, in December 1867. After this, hangings took place within the confines of the prison.

Until 1790, another punishment, being burnt at the stake, was usually a sentence suffered by females for offences including treason. The prisoner was usually strangled before being burned.

From the reign of Elizabeth I until 1771, if the defendant refused to plead or stayed mute a common practice was that the Crown would seize their belongings if they were found guilty. However, this was not as simple as a further action since they would also be ordered to be pressed. Pressing, or crushing, was known as a brutal and forceful punishment, the legal term in French being '*Peine Forte et dure*'. This was the prisoner's fate: they were stripped down to all but a scrap of cloth to protect their dignity and strapped down to the floor. The jailer then placed a board across their chest, and heavier and heavier rocks and iron were placed upon it, giving them the option to plead; if they did not, it continued until they died. This was something of a poisoned chalice. If the defendant pleaded guilty or was found guilty, the Crown would be entitled to seize all of their assets, leaving nothing for the next of kin. If they refused to plead and were pressed to death, the next of kin could retain their title and belongings. This did not apply if the offence was treason; if that were the case, they would lose their possessions to the Crown anyway!

One of the most common punishments was deportation to the colonies – Australia and the Americas. However, when America became independent in 1776, England lost its penal colony there. Botany Bay, in Australia, was to be a penal colony, but when Captain Arthur Phillip RN arrived in 1788, he found the

Burning at the
stake.

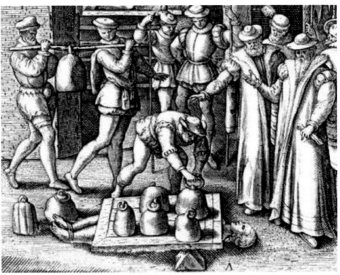

Pressing.

area unsuitable and moved it a few miles north to Port Jackson – now Sydney. It is here that criminals were sent on prison ships. Here is the experience of one female sentenced by the court and sent there:

> After a pretty good passage of six months, I take the first opportunity to tell you of my safe arrival in this remote quarter of the world. Since my arrival, I have purchased a house for which I gave £20 and the following articles, three turkeys at 15s each, three sucking pigs at 10s, a pair of pigeons at 8s, a yard dog at £1.

She described the items that she bought and sold, finding that she received better prices in the colony than in England, continuing:

> On our passage here, we buried only two women and two children; the climate is very healthful and likewise very fertile as there are two crops a year of almost everything. And I really believe with the assistance of God, by the time that I have paid the forfeit, according to the laws of my country, I shall acquire a little money to return home with which I have not the smallest doubt of, and to be a comfort to you at the latter end of your days. I conclude by giving my kind love to brothers and sisters, nieces, and nephews. I am dear father, your ever dutiful and affectionate daughter, till death. 'S.B'.

1

CRIMES AND THEIR SENTENCES

Before looking at individual cases, here are some examples of death sentences awarded for crimes:

1601	A woman named Candy was executed for conspiring to murder her husband. Her paramour, Boon, refusing to plead, was pressed to death in the castle.
1602	Arnet of Saltney side, servant to Mr Manley, hanged for murdering his fellow servant.
1651	Sir Timothy Fetherstonehaugh, a Royalist, beheaded in the corn market of Chester by order of the Parliament.
1689	John Taylor, gaoler of the castle, hanged for the murder of Mr Hockenhaff, a prisoner in his custody for recusancy (refusal to attend Church of England church services).
1692	William Geaton, servant to Bishop of Chester, for the murder of James Findlove, a Scottish peddler. William's body was hung in chains on Grappenhall Heath.
1760	Two Irishmen executed and gibbeted on the Parkgate Road, near the Two Mills, for murder.
1766	Executions of Peter Steers, for the murder of his wife, by poison. Edward Holt, for a burglary at Knutsford. Thomas Buckley, aged twenty, for a burglary at Chester.
1776	Execution of James Knight for burglary at Odd Rode. Christopher Lawless, Isaac Hutchinson, Alexander Solomon, and Isaac Josephs were executed for robbing the shop of Mr Pemberton, a jeweller. They were buried behind the Roodee-Cop, opposite Overleigh.
1777	Samuel Thorley, executed for the horrible murder of Ann Smith, a ballad singer, near Congleton. After cutting off her head, he severed her legs and arms from her body, which he threw into a brook. He broiled and ate part of her. He was hung in chains on the heath, near Congleton. [Mentioned again later in this book when his great-nephew was also a murderer.]
1779	Sarah Jones, executed for stealing 28 yards of chintz from the shop of Mr Meacock at Chester.
1779	William Ellis for burglary, and William Loom, discharging a loaded pistol at Charles Warren, of Congleton, executed at Boughton.
1783	Resolution Heap executed for a burglary at Whaley Bridge, and Martha Brown executed for a similar offence at Over.

1784 Elizabeth Wood, hanged for poisoning James Sinister at Bredbury. John Oakes was executed for coining (forging).

1801 Joseph Wood executed for stealing three sheep – the property of S. Hollinworth.

Name	Crime	Sentence
William Hamlett	Entering a warren in Delamere Forest and taking and killing two rabbits.	One month's imprisonment and a fine of 10s
William Wright	A charge of manslaughter at Knutsford.	Fined 10s
Jonathon Kinsey (28) and David Rigby (20) from Congleton	Stealing several pieces of printed calico from George Palfreyman of Wildboarclough.	Death
William Birch (46) from Ashley	Stealing two pigs – the property of William Birkin of High Leigh.	Death
George Brown, alias 'Bramwell', (34) from Sheffield and John Aldershaw from Stockport	Breaking into the dwelling house of John Smithman of Stockport and stealing 20 lbs of Italian silk.	Transported for seven years
Sarah Daran (22) from Stockport	The willful murder of her newborn male child – found guilty of concealing.	Imprisoned for two years in Chester Castle
David Vernon (24) of Middlewich	The murder of Daniel Patrick of Middlewich and being a deserter from the 43rd Regiment of Foot.	No True Bill*
Samuel Houghton	Breaking into the house of Daniel Wood at Werneth and stealing ten loaves of bread.	Death
John Morgan	Uttering a forged promissory note of £1.	Death

*This is a legal procedure that dismisses the charges against the defendant when the grand jury does not find enough evidence to charge them with violating the law.

DEEP, DARK DOINGS IN OLD NORTHWICH TOWN

In Northwich town there was a street called Church Street, a cobbled street of low caste terraced housing with a few shops and small businesses. The street has been swept away, as have many in Northwich. The town was famous for its subsidence due to the salt mining that went on there. Old Church Street stretched from the Bullring to Crum Hill, crossing Crown Street and roughly following the route of the present Chester Way. In 1894, that area was described as a slum, and at No. 26 there was a dark and dingy provision shop and boarding house. This became the scene of a truly evil deed.

The shop tenants were Mr and Mrs Deakin. Margaret Percival Deakin ran the small shop and boarding house. Her husband, James Deakin, worked for Brunner Mond at Winnington Chemical Works. The works were just a short walk away and would soon become the Imperial Chemical Industries (ICI). One of the tenants, Elizabeth Heald but known as Betsy, was described as an old lady. She was, in fact, fifty, and the sleeping arrangements were somewhat

Witton Street, Northwich, *c.* 1920.

Church Street, Northwich.

strange. The Deakins lived and slept in the parlour behind the shop on a sofa and chairs. Betsy slept in the same room on a mattress or palliasse. Margaret and Betsy were drinking partners and, putting it mildly, enjoyed a drink; they also quarrelled a lot. Betsy was a charwoman, and her brother Thomas Heald lived nearby at No. 12 Crown Street, where he was a greengrocer. One of the other tenants, Elizabeth Thomas, later said that Margaret Deakin was not jealous of Betsy but accused her of being a telltale. She said that Margaret had told her that Betsy was a bad 'un and tells her husband everything. She also said that Margaret had seen Betsy and her husband getting up to no good together. Margaret had herself been married three times, and the living arrangements were strange but, in those days, not that unusual. On Friday 26 January 1894, Mr Deakin got up and made a cup of tea for his wife and Betsy and made them another cup before going to work. He then set off to walk to Winnington. One of the tenants came down for some coal and saw what looked like a pile of covers on Betsy's mattress. She asked where Betsy was and was told that she had gone to Leftwich to see Mary Ann Plumb, a friend. An hour later, Margaret saw the tenant again. She was on the way to Winnington Works with her own husband's lunch, so she handed her the basket containing James Deakin's lunch to take as well.

Church Street in the opposite direction.

When James Deakin arrived home from work at 6.30 p.m. the front door was locked with no key in it. Entering through the rear door instead, he found that the parlour door was locked. He forced it open and went in. After a short while, he came out and went into the kitchen where one of the tenants, Phoebe Smith, was working. She noticed that he was pale and shaking, and he asked her to return to the parlour with him. Betsy's bed was partly uncovered. He pulled off the cover to see that her throat had been cut, almost decapitating her head, and a second cut had nearly reached her mouth. Her hand was lying loosely with a knife in it. The police were called, and PC Hunt arrived from the Cross Street police station and inspected the body. It was left in a way as to suggest suicide, but the officer soon disregarded this. There were other cuts across the body and to the throat and face. The bed was soaked in blood, as was the wall around it. Whoever had murdered her had placed the offending knife into her open hand in a rather pathetic attempt to make it look like suicide.

The Cheshire police circulated details to other forces. As a result, after information was received a sergeant from Northwich joined a Manchester officer and searched the city. The officers found Margaret Deakin in Gregson Street, Deansgate. She was taken to the local police station and a female officer searched her, finding bloodstains on her skirt, shirt, the shirt cuffs, and a key in her possession, which was the house key and was also bloodstained. Margaret was conveyed back to Northwich by train.

Northwich railway station.

She went before the police court and was remanded in custody to Knutsford Prison to await a hearing at Northwich magistrates' court. Additional evidence was given disclosing other times where the defendant had assaulted Betsy. Mary Newall was the offender's daughter and lived at No. 134 Greenall Road, Witton. She said that she last saw her mother on 26 January at the shop's parlour door. She did not enter, but her mother, Margaret Deakin, handed her ulster (a Victorian daytime overcoat with a cape and sleeves) to her and walked off. Eliza Philbin of No. 9 John Street was called as a witness and said that she saw the defendant passing through the stile between John Street and Church Walk and saw blood on her. Other witnesses were called, and she was committed to Chester Assize Court.

The jury found Margaret guilty of murder but recommended her to mercy due to her advancing years – sixty-four – and the limited life expectancy at that advanced age. However, the sentence for murder was hanging, so the judge handed it down and returned her to Knutsford Prison to await the death sentence.

Hanging a woman, especially one of advancing years, was repugnant to many, and an appeal was made to the only person who could commute it – the Home Secretary. The governor of Knutsford Prison subsequently received a letter from the Home Secretary commuting the death sentence to penal servitude for life.

In 1901, she was recorded as residing in Aylesbury Prison in Buckinghamshire, and she died in September 1905 at St Marylebone, London. At that time, she would have been at Holloway Prison; she was at the age of seventy-six.

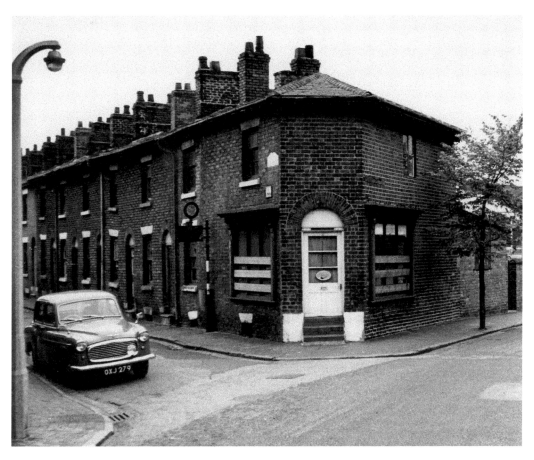

Above: John Street.

Right: Aylesbury Prison.

MACCLESFIELD CHILD KILLER

In March 1877, Mrs Emily Halton, a widow, was in her terraced house in Fence Street, Hurdsfield, Macclesfield. A widow of just two months, she lived with her eight-year-old daughter Mary-Ann and worked at Bamfords Silk Mill in Pool Street, Macclesfield.

The town was the centre of the world's silk industry and was the western end of the Silk Road from China. Mr and Mrs Leigh lived in the house next door. Mrs Halton had gone to the Leigh house and noticed that their son, described as a dwarfish man of 4 feet 8 inches by the name of Henry Leigh, was present. This was not unusual as he lived nearby in Paradise Street with his wife and he was known to Mrs Halton. During the conversation with his parents, she happened to mention that she was too sick to go to work at the mill the following day. As a result, she explained she would send her daughter, Mary-Ann, to collect her wages from the office.

On Saturday morning, two boys attended Bamfords Silk Mill with a letter purportedly signed by Mrs Halton asking for her wages of 12s 3d. The manager was not happy and refused to hand over the money. It consisted of 4 half-crowns and some other change and at 10.30 a.m. on 24 March 1877 Mary-Ann left to

Macclesfield town centre.

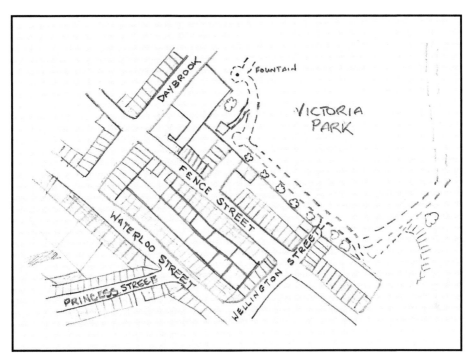

Above: Hand-drawn map of long-gone Fence Street.

Below: Paradise Street.

Pool Street – the location of Bamfords Mill.

collect the wages. It reached a little after 1 p.m. and Mary-Ann had still not returned, so Mrs Halton went to the mill to enquire after her. The manager explained the note, showing it to her, and she told him it had not been written by her and asked after her daughter. She was told that the wages had been handed to her, and she had left some time earlier. By now Mrs Halton was getting very worried and somewhat suspicious when the man told them that the two boys stated they had been given the note and instructions by a 'little spare [short] man'.

A girl's body was taken out of the canal near Hollin Bridge at around the same time. There were several marks of violence on the body, and the pocket of her smock had been torn open. At this time Mrs Halton was unaware of the sad discovery, but what she had heard pointed to Henry Leigh being the perpetrator. She went to his house and asked if he had sent the note with the boys, but he denied it and said he had not seen them. She told him to forget the money and just tell her where her child was, but again he denied any knowledge.

She later identified that the body taken out of the canal was Mary-Ann. After a brief investigation, the police went to the home of Henry Leigh. His wife's sister commented that there were police officers in the street and he immediately

Hollins Bridge.

ran from the house, scaling a wall; he was not seen again for several hours. The police continued to investigate, returning to the Leigh house because of further information. After a search, he was found in an adjoining outhouse with the door locked. The door was forced, and he was arrested. The two boys who were given the note identified Leigh as the man who gave it to them, and a black lead pencil was found on him. Another boy said he had seen Leigh walking up Windmill Street with the young girl. Windmill Street led to the canal and, hearing the girl's description, it was obviously Mary-Ann.

On the following Wednesday, Leigh was brought before Macclesfield Borough Magistrates. Then followed a series of questions that could be heard today. Whose patch was the crime scene? Macclesfield had its own borough force with its own chief constable, and the canal was the boundary, so was the offence in the borough or Cheshire county? It was eventually decided that it was on the county side and so it could be dealt with there. Superintendent Sheasby of the borough force handed over Leigh to Superintendent Dale of the county police. Leigh was placed in the county police cells in King Edward Street (the building remains,

Windmill Street.

although now converted to apartments). Both the borough and county police were investigating the murder.

A married woman spoke of seeing a man fitting Henry Leigh's description hanging about by the Wheatsheaf pub at the time the girl was going to the nearby mill, and he was carrying a brown basket. This basket resembled the one found at the scene of the crime. It contained a dish, and one of the boys identified it as one Leigh was carrying when he saw him.

Although Leigh had been out of work for weeks, he handed his wife 3 half-crowns and a sixpenny piece. The police found a half-crown and a sixpence hidden in the outhouse where he was arrested. The evidence was sufficient to charge him, and he was brought before the police magistrate and charged with the capital charge of murder and a charge relating to him trying to commit suicide in the police cell. Even before the court opened a large crowd had gathered in King Edward Street hoping to get a glimpse of the prisoner. The court was instantly filled to capacity when it opened, and some had to be turned away. A man shouted to the superintendent in the packed courtroom to sit the defendant on a chair set upon a table to enable the crowd to see him. Another indignant onlooker asked if Leigh could be handed over to the crowd to be dealt with. The prisoner treated these comments with a contemptuous smile. After the evidence had been heard he admitted he'd tried to commit suicide, but he had not committed the capital offence and had not seen the girl that day. He was committed to stand trial at the assize court at Chester. When leaving the court, he made a few comments to

Police cells, King Edward Street.

the onlookers. One of his friends shouted, 'Goodbye,' to which he replied, 'Nay, lad, I shall none say good-bye.' The crowd lingered at the court and the railway station, and it was decided to convey him by a trap to Chelford and then by train to Chester, thereby preventing his capture by the crowd. The mayor set up a subscription list to help compensate Mrs Halton, who had just lost her husband and was destitute. The public gave generously, and the body of Mary-Ann was laid to rest in Macclesfield cemetery.

The murder had taken place on 24 March 1877, and the trial of Henry Leigh commenced on 26 July 1877. He pleaded not guilty. The jury took an hour to review the case and find Leigh guilty on all counts. He was sentenced by the judge to be hanged and remanded to Chester Castle to await the sentence. While there he asked for a letter to be sent by the prison chaplain to Mrs Halton:

Dear Mrs Halton,
Harry Leigh has made a full and particular confession of his crimes to me. He meant simply to deprive you, a poor widow, of your hard-earned money by means of a forged note and after dealing thus to you, because your poor little girl screamed that she would tell her mother that he robbed her, he diabolically pushed her into the canal, left her to drown cruelly and went off to spend the first fruits of his plunder on drink … You have no other child, and your poor little Mary Ann must have been a comfort to your life. Leigh, who is beside me in his cell as I write, describes her as such a dear, good, little child liked by everybody …

Above: Macclesfield Cemetery.

Below: Chester Castle Square.

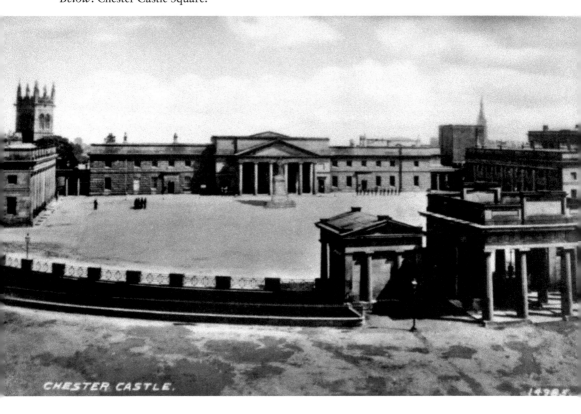

The letter continued bewailing his crime and asking her to forgive him. Mrs Halton, after talking with the mayor and curate of Hurdsfield, replied that she did forgive him and urged him to prepare for the doom that awaited him by seeking divine forgiveness.

The customary three Sundays were allowed to intervene between condemnation and execution. Eventually, however, it was time to carry out the judge's sentence. Half an hour before the time of execution a considerable crowd had gathered in the Castle Square. According to law, the high sheriff (Lieutenant-Colonel T. U. Brocklehurst) and Mr John Tatlock (acting Under Sheriff) arrived. Henry Leigh was brought from the prison in a procession led by the chaplain and surrounded by several warders and Mr Marwood, the executioner, together with other dignitaries as required by law. His arms had already been pinioned before leaving the condemned cell. At the gallows he was hanged and his body cut down, then after an hour it was taken to the deadhouse for the statutory inquest. A man who had committed a truly evil deed and had been duly tried and found guilty, then admitted his guilt before facing his punishment. He would no longer be a danger to anyone.

4
THE STORY OF 'NUTTY ANN'

The Three Greyhounds Inn at Allostock had been a pub since 1757 as it was a former farmhouse owned by the Shakerley family. A gentleman by the name of Thomas Hockenhull was the landlord and lived there with his wife, Alice, between 1821 and 1831. After 1831 his wife is listed as the incumbent, so what happened to Thomas? Around 1831 Thomas went to Northwich where he was seen in the company of Ann Griffiths, alias Ann Burns. This lady was better known in the area as 'Nutty Ann', though the reasons for this are not as you may think: she was an itinerant nut seller. She lived in Tarporley and was well known as she attended various fairs and markets to sell her nuts. During the day Mr Hockenhull somehow ended up in the River Dane and was heard screaming for help, though he was dead when he was eventually pulled from the water. The police attended and Nutty Ann and another woman were arrested on suspicion of pushing the poor man into the river and murdering him. They were brought before the court and the evidence was examined, of which there was very little. No witnesses saw him fall into the water.

Three Greyhounds pub.

The magistrates decided that there was insufficient evidence to charge them, so they were released.

In 1851, Nutty Ann lived with her two sons in New Street, Northwich – the street is now under the police station and surroundings. She was head of the family, and her job title was a confectioner. In 1856, Ann went to see a friend in Leftwich and died while there. Before doing so, she lay on a bed in a sad state, obviously in the last minutes of a long life. Expecting to meet with God, she decided to make a dying declaration, knowing that she could no longer face the penalty for what she had done. Her admission was that on the day that Mr Hockenhull ended up in the River Dane in her company, he had been very drunk.

She had robbed him and then pitched him into the river, taking advantage of the situation. Ignoring his cries for help, she stood back and allowed him to drown. Being aware of the penalty for murder, she kept quiet during the many years in between. So, his wife Alice may not have known of this admission as she took over as landlady of the Three Greyhounds, remaining there from 1834 to 1841. She knew that her husband was not opposed to having more than one drink and assumed that he had fallen into the river and drowned in one of his intoxicated states. And there ends the tale of 'Nutty Ann' and her nefarious, unpunished deed.

River Dane.

5

CHESTER POLICE OFFICER MURDER

On 6 December 1788, a resident of Handbridge, Chester, was heard by two neighbours shouting 'help' and 'murder'. She was seen at the window with her face bloodied before being violently dragged back and away from view. The offender was Thomas Mate, and the woman was his wife. This was not the first time Mate had assaulted or abused his wife, and the two neighbours went to a magistrate and swore on oath as to what they had seen and heard. They also said she had frequently told anyone who would listen that she was terrified of her husband, believing he would eventually murder her. As a result, the magistrate immediately signed a warrant ordering the police to attend and take Mate into custody.

Four constables attended at the house, including Constable/Peace Officer John Parry. Upon arrival the officers found the door locked and ordered it to be opened. The officers forced the door and, with Parry leading, they headed for the stairs to the room they were aware that Mate was. As John Parry entered the

Chester.

Handbridge, Chester.

room Mate immediately fired a gun, hitting him. The ball lodged in his chest, and within a few minutes he was dead, leaving a wife and six children to lament his loss. Parry was an outstanding and well-liked officer whose life had been brought to a sudden end. After carrying out this evil act, Mate fastened the door shut and threatened destruction to anyone who tried to take him. As a result, the magistrate called upon Major Adlam, commanding officer of the 40th Regiment, to assist the Civil Power to apprehend this daring offender. The major instantly consented to this and, with a detachment of soldiers, arrived at the house led by a peace officer, who told them to break down the door. Mate, seeing the opposition, immediately surrendered. He was arrested and taken to Chester Gaol at Northgate. On 13 December 1788, Thomas Mate, a labourer, was charged at the coroner's inquest with the willful murder of John Parry, a peace officer in the execution of his duty. He was remanded to Chester Court.

At Chester Crown Mote Court, Thomas Mate was arraigned for the murder of John Parry. After a trial of nearly five hours, he was fully and clearly convicted of willful murder. The judge ordered that he be executed on Wednesday 4 February 1789, and then his body was to be delivered to the surgeons for dissection. From his arrest to his eventual end, Mate displayed an almost savage obduracy that the most solicitous and arduous attempts by a reverend divine could not shake from him. He displayed no sorrow or grief for the crime that he had committed.

While on the brink of a dread eternity when he was about to launch into the presence of an offended God, the inexorable spirit of this poor creature loudly declared he would not forgive his prosecutors and particularly his wife, whom, though near seventy years old, he charged with infidelity. This impressed the heart of every spectator with a mixture of horror and astonishment. In short, he fell at the age of sixty-four, a lamentable example of human depravity.

Addendum

Crown Mote and Port Mote Court are ancient titles that essentially allowed the mayor of Chester to try any offence other than traitors. They could also determine civil actions. The courts were held 'before the Mayor and Recorder'. The mayor presided, but only the recorder could pass sentences of death. The jurisdiction of these courts applied throughout the city from Arnolds Eye opposite the castle to the Red Stones at Hoylake. That is a simplistic and incomplete explanation for the Crown Court Mote in this story.

6

THE WINSFORD CULVERT MURDER

In Manchester in early 1946 the war had ended and people needed the service of moneylenders to see them through the post-war shortages. The work of moneylenders increased, and they were advised to ease the restrictions and checks and expedite post-war formalities of borrowing. But because of the following story these more straightforward formalities were rescinded, and pre-war practices returned. One of the men employed as a moneylender's manager at the Refuge Lending Society in Walker Street, Manchester, was Bernard Phillips of Meade Hill Road, Prestwich, who was thirty-seven years old and married with one child. It was his job to loan to people of good character and respectability, and this he thought he was doing on 3 January 1946. On this day a man came into the office to apply for a loan. He wanted £60, equating today as £2,529.43. He gave the name George Wood with the address of Moss Side Farm in Tarporley, and his wife's name was Jessie. The receptionist sent him over to Mr Phillips, who, believing that a Tarporley farmer was a good risk, approved the loan but only after it was agreed that he was prepared to hand over the farm's deeds as surety.

The papers were signed and arrangements were made for Mr Phillips to come to Cheshire and meet Mr Wood to make the exchange. The office had a car for

WINSFORD, FROM HILL STREET.

Winsford.

the use of the staff, a black Ford 8 saloon. Mr Phillips agreed to meet Wood at his home the following weekend to take possession of the deeds and hand over the money.

Within half an hour of leaving, the man giving the name Wood returned and asked if the visit could be that day as he was going away with his wife. Mr Phillips left the office with the so-called Mr Wood and in possession of £60 made up of £1 and £5 notes. They went in the company car, supposedly to collect the deeds, which was the last time the office staff saw him alive.

When he did not return, the Manchester police were informed and circulated his details and those of the car. The car was found in a secluded lane at Moulton (a small village near Winsford). A search revealed a box on the back seat with five eggs in it, but these were not in the car when Mr Phillips left Manchester. His briefcase was also missing. The chief constable of Cheshire, Sir Jack Beck, circulated details of the vehicle, asking that the persons who had sold petrol for the car and the eggs could come forward. In the meantime, a search was started to find Mr Phillips and the man known as Mr George Wood. The seller of the eggs was found at Wellington in Shropshire. The seller, Mr Dutton, was interviewed and stated that the man known as George Wood was driving the car, indicating that the vehicle had been there before travelling to Moulton. At the CWS farm he purchased the eggs from Mr Dutton. The eggs' story was an essential piece of police evidence, although the details surrounding the trip to Shropshire are vague.

On 5 January, two young brothers, Donald and Fred Threadgold of Deakins Road, Wharton, were returning from an errand in Moulton. The boys walked along the path from the start of the railway tunnels under the West Coast Mainline Railway between Moulton and Meadow Bank. They walked towards the Smoke Hall Lane bridge over the railway and were pushing a heavy barrow. It got stuck in the mud near the bridge, and they struggled to release it. Nearby was an embankment and the narrow Smoke Hall Lane bridge crossing the railway tracks. One of the brothers, fifteen-year-old Frederick Walter Threadgold, happened to look down from the bridge. Below he saw a man's body lying at the bottom of the embankment in a culvert. The boys alerted the people in a nearby cottage and then ran off to tell the police. As a result, Sergeant John Nixon attended with Dr Leak, and the doctor pronounced life extinct. The location of the body was only 400 yards from the scene of the abandoned car. The body was that of Bernard Phillips.

The pathologist, Mr Grace, attended and, on moving the body, found the murder weapon underneath. It was a 'commando' knife, later identified as belonging to Harold Berry, and it had been used to stab Phillips in the back driving the blade between the ribs. He estimated that death had occurred some forty-eight hours previously. The later post-mortem found that the knife had entered the lung through the third and fourth rib. There were no personal possessions on the body.

Smoke Hall railway bridge.

Detectives commenced their enquiries, which included interviewing the servicemen stationed at Oulton Park, a demobilisation camp. Extensive investigations were carried out in Winsford. The enquiries led to Harold Berry, a local man from Ledward Street.

Investigations continued, and Berry's house was searched. In a lady's handbag on the baby's pram, the deceased's wallet was found by Sergeant Nixon; it contained £22 10s. William Dodd, a tailor of Winsford High Street, stated that he sold Berry an overcoat for £5 5s. Slowly the truth was drawn out. One person commented that he had given Berry a lift to Manchester with a workmate – Irene Wynn.

Harold Berry, who had given the name George Wood, was a thirty-year-old night watchman at the CWS bacon factory and lived at No. 55 Ledward Street, Wharton, Winsford. He did not own a farm nor deeds to one. He was having an affair with twenty-one-year-old Irene Wynn, a married woman whose husband was abroad in the army. She also worked at the bacon factory and lived in Station Road, Winsford.

Above: Railway embankment at the side of Smoke Hall railway bridge.

Below: Ledward Street.

Winsford bacon factory.

On 5 January, after getting a lift to Manchester, they spent the night in a hotel before catching the train to London. They travelled first class on the train and booked into the Euston Hotel, near Euston station. Money appeared no object, and Irene was given flowers, grapes, trips to the theatre and other treats during the two days in London.

On returning to Winsford, Berry was searched and found to be in possession of items stolen from Mr Phillips, consisting of a wallet and cigarette lighter belonging to the deceased. Money from the moneylenders was recovered in the Euston Hotel where they stayed. The receptionist at the Euston Hotel identified Berry as the man who stayed there with a young lady. Berry was arrested for the murder and appeared at Northwich Police Court on 23 January 1946. In the court was Mrs Phillips, the murdered man's wife. She was there to give evidence, and she identified the cigarette lighter found on Berry when he was arrested. She stated that it was the cigarette lighter she bought for her husband when they were engaged to be married. Berry was remanded to Strangeways Prison in Manchester to await trial.

On 4 February 1946, he was tried for murder at Chester Assize Court. He pleaded not guilty and the defence barrister was Mr H. Edmund Davies KC. The offender was cross-examined for four hours. He stated that the wallet and lighter had come from a sailor he had worked with, and the money came from a 40-1 bet. He had never been to the moneylender in Manchester and had never met the deceased Phillips.

Berry was found guilty, and the judge, Mr Justice Stable, said, 'Harold Berry, the jury has found you guilty of the murder of Bernard Phillips. That is a right and proper verdict. I think you know that you murdered and robbed him of £60.' He then sentenced Berry to death by hanging. The sentence was carried out at Strangeways Prison in Manchester on 9 April 1946, and the hangman was Albert Pierrepoint. He was also the executioner in the Nuremberg Trials of War Criminals.

As for the eggs in the car: we know where they were purchased but not what the car was doing in Wellington Shropshire. Mrs Wynn passed away in Middlewich in 2004 at the age of eighty.

UTTERING FORGED BANKNOTES

Uttering is the offence of passing a forged document to someone to defraud them – usually money. It is a serious offence today, but in the 1800s it was more so, as we will see.

In 1817, Joseph Allen lived at Onston, near Weaverham, a quiet country village not used to seeing offences more common in the cities. But a crime of uttering forged bank notes was committed by Joseph Allen, who lived at a farm with his wife, seven children and his mother. Allen was a market trader in Manchester dealing in cheese, flour, fruit, etc. Suspicions in Manchester and Cheshire were raised by the banknotes with which he paid for his wares to sell at the market and his day-to-day living. The notes uttered by him were marked and presented to Mr Nicholson, a solicitor in Warrington. Some of the witnesses later appeared at his trial at Chester Assizes. Samuel Woodward, a joiner at Acton Bridge, was paid by Allen £9 in £1 notes. He paid £8 of them to Mrs Okell for potatoes. She, in turn, used them to pay several people, all of whom returned the notes to her and then she passed them to Mr Nicholson.

Onston, Crowton.

Acton Bridge, the location of uttering £9.

The evidence was mounting, and the police acted. PCs Tinsley and Caldwell from Warrington attended Allen's farm. PC Tinsley searched the house, leaving PC Caldwell to detain Allen and his wife. On a desk, he found thirteen £1 notes, and nearby were a further six. On most of them were written the name Jelley and two other names in ink that was barely dry. When questioned about this, Allen said that he did not want to use them as they were rather ragged, and he was going to return them to the person he got them from, Joseph Jelley.

An officer from the Bank of England inspected the suspect banknotes and declared them counterfeit. He stated that he believed them to have been printed on the same plate, and the handwriting on them was in the same hand – this related to the forged signatures of the persons who usually signed them at the Bank of England.

Joseph Allen was indicted for uttering forged notes. Most of the witnesses gave evidence that they had known Allen for some time and found him to be a good and honest man. When Allen was invited to comment, he stated that he had received all the notes from Jelley and others – a story that he stuck to throughout. A miller at Onston, John Davies, said that he had never dealt with as honest a person in his life. Samuel Hignett of Onston Hall was Allen's landlord at a farm in Onston, near Crowton, said that he paid rent on his farm of £200–£300 a year and he believed him to be an honest man. In fact, most of the witnesses who were called vouched for their faith in Allen.

Sir William Garrow, the Chief Justice addressed the jury at Chester Assizes; the character witnesses all vouched for the respectability of Allen. But if he denied having forged notes in his possession and was then found with more when arrested, it must indicate a degree of guilty knowledge. The jury found Allen guilty as charged. The Crier of the Court then instructed all present to be silent whilst sentence of death was passed on the prisoner.

Chester Assize Court.

The chief justice and magistrates then put on their hats, and the chief justice told Allen that he had been tried and found guilty by a jury of his countrymen of a grievous and aggravated crime. He had paid £140 (today worth £12,302.51) in forged notes to several different persons. It had then become his duty to pronounce upon him the awful sentence of the law – that all the court may know his fate. To see a man that had filled so respectable a situation and guilty of so great a crime, he told him, that it was now up to God to show mercy as there was no chance of any on earth. He continued at length until the time came to sentence him, 'that he, Joseph Allen, be taken to the place from whence he came and then to a place of execution, where he should be hanged by the neck, till his body is dead – and may the Lord have mercy on his soul'.

Allen exclaimed, 'Eh! dear, dear, what a great change I shall shortly undergo on the way through Chester castle prison.' On arrival at the Gloverstone, the county boundary where the sheriffs were waiting, he was handed over. The cavalcade moved off and arrived at the City Gaol. The preparations for the drop were completed, and he ascended the steps to the platform where the executioner applied the noose. After prayers, he gave the word and the platform fell, and he was ushered to 'that dread bourne from which no traveller returns'.

On completion, he was taken down and conveyed by hearse in a handsome coffin paid for by some gentlemen from Weaverham. The following Sunday his body was interred in Weaverham Churchyard. The people of Weaverham had a collection for his wife, mother and seven children as they were rendered destitute by his loss. What happened to Jelley and Allen's brother, who were also implicated in the crime? Joseph Jelley was tried at Lancaster Assizes and acquitted. Samuel Allen, his brother, was also tried at Lancaster, was found guilty and sentenced to fourteen years' transportation to the colonies. The forgers of the notes were not found.

Above: Chester Castle, once home of the gaol.

Below: Weaverham Church.

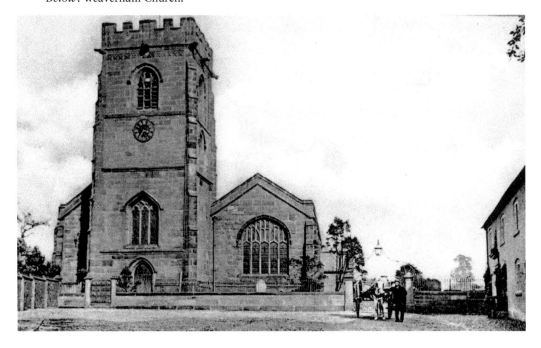

A MIRACLE CURE WITH A SAD ENDING

On Saturday 5 October 1760, a letter from Thomas Heald, a reputable farmer of Tatton Old Hall, near Knutsford, was used for advertising a miracle cure.

The curing of his wife Mary proved the efficacy of this cure. It was published at their earnest request for the information of all afflicted with rheumatism, etc. In the letter (slightly amended into everyday speech, mainly some Fs are Ss), Mary wrote in her own hand:

> I Mary, the wife of Thomas Heald having taken Cold after lying-in, was seized with violent Rheumatick Pains in my Limbs and Body, which were frequently moving from one Part to another, from which I was never free for more than three years, notwithstanding I had the Advice of the most eminent Doctors in the Neighbourhood and I took great Quantities of Medicines, but to little or no Effect, for my Pains were daily increasing, and at last became so intollerable, that I could take no Rest; I was withall afflicted by a very bad Cough, Loss

Tatton Old Hall.

of Appetite and Shortness of Breath, which soon reduced me so low that I soon became quite Helpless, and my Body Hips and Thighs swelled and a shooting Pain in one of my Legs, in such a Manner that my friends thought I had the Dropsy; In this Miserable condition I continued three Quarters of a Year, ex-pecting every Day to be my last, but happily my husband fetched an advertisement for the great Virtues of Dr Batemans Original Pectoral Drops (prepared by Dicey and Okell, in Bow-church yard, London) persuaded me (as the last Hopes) to make a Trial of them and directly sent for a Bottle to John Leeck's, Bookseller, &c. in Knutsford; In a few Hours after I had taken the first Dose. I found ease and rested well all Night, and by continuing a few Doses, I began to feel the use of my Limbs return, which encouraged me to proceed, and by taking a few Bottles more, (with the Blessings of Divine Providence) my Pains left me, my Cough ceased, my Appetite returned, the Swelling of my Body. &c. was quite reduced, and I soon recovered my former Health and Strength, which I have ever since, (now more than a Year) perfectly enjoyed.

Also, I Thomas Heald, was relieved of the rheumatism, by one Dose only. Of the said Drops: Likewise, our Daughter and several of our Neighbours (to whom we recommend them) having received great Benefit thereby.

<div align="right">October 27th, 1759
Thomas Heald & Mary Heald</div>

This was used in an advertising campaign using pamphlets and posters. By April 1762, this couple, devout Quakers, were not getting on so well. The now healthy Mary was falling out of love somewhat with her husband of twenty years. The fallout was so virulent that on 19 October 1762 Mary dosed her

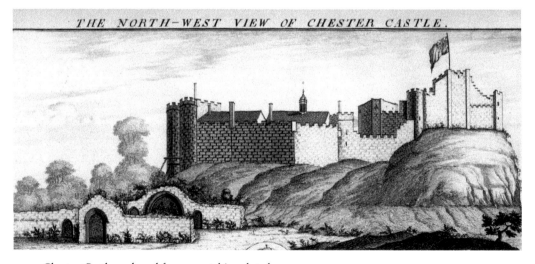

Chester Castle and gaol from an etching dated 1747.

husband's porridge (Mess of Fleetings) with arsenic poison. Within five days he had died and gone to meet his maker, and she was removed to Chester Castle Gaol to await trial.

On 19 April 1763 at Chester Assizes, she appeared charged with 'petit treason' and was found guilty. The sentence was that she was to be burned three days later. The date was changed on the application to Saturday 23 April 1763. On this day, soon after 10 a.m., she was taken from Chester Gaol to the Gloverstone. Here, the gaoler of the castle delivered her to the sheriff of Chester. They placed her upon a sledge that was dragged through the city to Spital-Boughton, where she was allowed private devotion with a minister.

After this, she was fixed to a stake on the north side of the road, almost opposite the gallows. She was first strangled, and then around her was placed wood and faggots, pitch barrels and other combustibles. The fire was lit, and her body turned to ashes. She behaved with much decency and left a full written admission to the heinous crime leading up to the execution. She was also the last person to be burned at the stake at Chester.

Burning at the stake.

The below advertisement containing her letter and compiled by her husband for Dr Batemans Original Pectoral Drops was still to be found in newspapers and other advertising locations. The bottom of the article is transcribed, this time as originally printed:

Alfo, Mary Heald of Tattenhall, near Knutsford and feveral in the neighbourhood have been cured of the Rheumatifm, &c. Likewife.

The above Drops have done many extroadinary Cures in the Ague, or Shaking Fever, in taking them juft as the Fit comes on; In Glouceftershire, Shropfhire, Chefhire, and Lancafhire.

So, nine years before she was named in this advert in 1772, she had been burned at the stake.

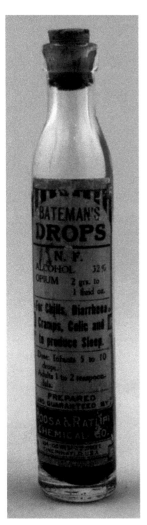

DICEY'S Original and the Only Genuine

DR. BATEMAN'S PECTORAL DROPS; the most valuable medicine ever discovered for Colds, Coughs, Agues, Fevers, Rheumatism, Pains in the Breast, Limbs, and Joints, and for most Complaints where Colds are the Origin. Sold in bottles at 1s. 1½d. duty included.

As there are various Imitations of this excellent Medicine by different Pretenders, all of them utter strangers to the true Preparation, Purchasers are requested to be very particular in asking for " DICEY'S BATEMAN'S DROPS," as all others are Counterfeit.

Sold by Sutton and Co. (late Dicey and Sutton,) at the Original Warehouse, No. 10, Bow Church-yard, London; also by Groves, Weymouth; Clark, Criswick, and Pouncy, Dorchester; Butler, Wareham; Moore and Sydenham, Butler and Randall, Poole; Groves, and Tucker, Christchurch; Martin, and Groves, Lymington; Fletcher, and Gilmore, Southampton; Roberts, Bridport; Simmonds, and Shipp, Blandford: Wellman, Jersey; and by most respectable medicine-venders, in bottles at 1s. 1½d. and 2s. 9d. each,

Of whom may also be had,
DICEY'S true and genuine DAFFY'S ELIXIR, in bottles at 2s. and larger ditto at 2s. 9d. each.
DICEY'S Anderson's or The TRUE SCOTS PILLS, 1s. 1½d. the box.
Dr. RADCLIFFE'S ELIXIR, 1s. 1½d. the bottle.
BETTON'S BRITISH OIL, (the only genuine,) 1s. 9d. the bottle.

Above and left: Bateman's Original Pectoral Drops.

CREWE MAN MURDERS NEPHEW

In 1875, Crewe was a busy railway town with a major locomotive manufacturing works. The town was built by and for the railway, which included rows of terraced houses for the workers. One of those houses was in Alfred Street, Crewe, and it was there that James Halfpenny lived with his wife, Mary. Only two weeks earlier she had given birth to a boy, and they had named him Henry. Also living as a lodger at the house was Mrs Halfpenny's brother, Charles Dentith. In May 1875, the demeanour of Charles Dentith was one of depression; he was twenty-eight years of age and had been in a permanent state of despair for two months.

On 22 May, Mr Halfpenny stated that he was going upstairs for a clean shirt. From the bedroom he shouted for his wife to come and find him one, and she left Dentith alone with baby Henry in his cradle, asleep. About two minutes later he started to walk down the stairs when he heard Dentith call up, 'Oh, Jim, come and see what I have done.' Henry's father ran downstairs, thinking that due to the sad

Crewe centre today.

state his brother-in-law had been in for some time he may have done himself harm. On walking into the front room, he found Dentith on his knees with a knife in his hand. Thinking that the man had slit his own throat, Mr Halfpenny said, 'Oh, Charlie hast thee cut thy own throat?' He put his hand under his chin and lifted it looking for a knife injury, but there were none. He walked over to the baby's cot and, moving some of the covers, he saw blood on the pillow. The baby was gulping for air and his head had several wounds, one of which revealed the brains were sticking out. Mr Halfpenny looked over at him and said, 'Oh Charlie, what hast thou done? Thou'st killed the child!' Dentith made no reply but threw the knife behind the cot. Mr Halfpenny investigated the baby further and said, 'It's been stabbed.' At which Mrs Halfpenny, who by then was present, became hysterical.

The next-door neighbour came in, and Mr Halfpenny went for his in-laws. Doctor Lord and two police officers also arrived. The doctor examined the baby, which was still murmuring, and believed nothing could be done. He said to Dentith, who was still kneeling on the floor, 'Are you quite well?' To which he replied, 'I've had a pain in my head.' The doctor turned to the weeping woman and said, 'Don't cry, the deed is done, you can't mend it. He is clearly insane and not accountable for his actions.' The officers arrested Dentith. The baby eventually passed away at 10.30 p.m. on the same night – around four hours after the assault. A postmortem revealed around twelve knife wounds in the baby's head. At the inquest, the coroner instructed the jury to ignore any suggestion that Dentith was mad; it was for the trial judge if this was the case. He was charged with willful murder and committed for trial at the Chester Assizes.

The case was brought before the lord chief justice and started with an investigation to see if Dentith was fit to plead. Doctor Lord and a second doctor, Doctor Bayley of Crewe, declared that he was not fit to plead. His lordship asked the governor of Chester Castle prison if the prisoner was fit to be brought up, and he said, 'Quite fit, my lord.' The investigation and cross-examination continued but not to find him guilty or not but to decide if he was mentally ill. The jury retired to determine the case and, on return, stated that they believed him to be insane and not in a fit state to plead. The judge sentenced him to be detained at Her Majesty's pleasure. He was sent to Broadmoor Criminal Lunatic Asylum at Crowthorne, Sandhurst, in Berkshire.

In 1881, James and Mary Halfpenny lived with their daughter, Martha Jane, who was at school at the age of eight. They lived at No. 12 Stafford Street, Crewe. In 1891, the family lived at No. 26 West Street. In the 1901 census the family lived at No. 30 West Street, Crewe. Martha Rhead, Mary's mother, lived with them as a widow, possibly having married for a second time.

By 1911 Martha Rhead had reverted to Martha Dentith and was head of the family, living at No. 95 Chetwode Street, Crewe. Her son, Charles Dentith, the murderer, and her son-in-law, James Halfpenny (father of the murdered baby), were boarders at the house. Mary Halfpenny was not living there as she had passed away in 1904.

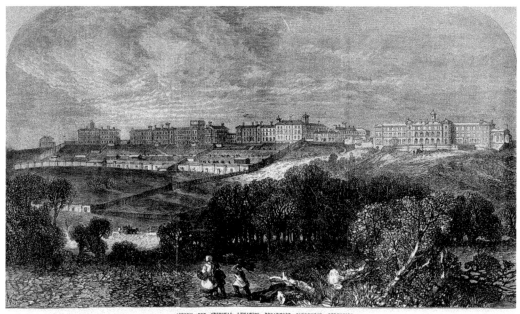

ASYLUM FOR CRIMINAL LUNATICS, BROADMOOR, SANDHURST, BERKSHIRE.

Above: Broadmoor Asylum.

Right: No. 95 Chetwode Street.

MURDER MOST FOUL IN WHARTON

In Station Road, Winsford, on 12 October 1908 ten-year-old Elizabeth Warburton, known as Eliza, played with her friends, including her twin sister Phoebe and other friends of the same age Fred Blagg and Lillian Goulding. A twenty-one-year-old unemployed painter and local man James Phipps approached the children as it was getting dark. He asked if one of them could go to a nearby shop and get him some cigarettes; the volunteer would get 2d for going. Eliza, being a kind and helpful girl, volunteered. She went and bought the cigarettes and when she returned with them Phipps asked her to show him where a man called Hulse lived. Eliza knew Hulse as the local lamplighter from Ledward Street. Again, the ever-friendly Eliza agreed.

They were seen walking along the footpath in Ledward Street at 7.30 p.m. The vibrant, fun-loving Eliza Warburton was last seen near Wharton Church by a neighbour. She was not seen alive again.

Phipps was known in the area, but he had one eye covered by a scarf due to losing it as a child when a stone hit him in the playground. When walking off

WHARTON VILLAGE, BY THE CHURCH, WINSFORD.

Wharton.

Ledward Street.

School Road.

with Eliza, a local lady named Mrs Rose Latham and her husband George of Station Road had seen the pair and called Eliza to come back. Eliza looked back but carried on walking. Mr Latham recognised Phipps and knew him to be a rather unpleasant man, so they told her sister Phoebe to go and tell her dad about Eliza and the man.

Mr Walter Warburton was a salt boiler. They were not particularly well off and had five children. Her father set off to search for his daughter. He walked to the end of Ledward Street and along the path known as Coronation Road, but there was no sign of her, so he returned home. Several locals, including Mr Warburton and Mr Latham, searched for the little girl again. When news got around they were joined by a large crowd. The group came upon Phipps walking across Middlewich Field towards the stile near the top of School Road. He ran off on seeing the advancing crowd; by now more than twenty to thirty people were chasing him. A cyclist caught him and the local policeman, PC Jones, took hold of his arm. The cyclist told the officer that Phipps had been interfering with a young girl. When asked by the officer if this was true, he agreed to tell him at the police station. When taken to Wharton police station Phipps explained that children threw stones at him. He had grabbed a girl and wrung her neck, throwing her body into a ditch. Sergeant Beech attended to guard the prisoner and PC Jones set off to join the search.

By the time the officer reached them the body of young Eliza had been found by a local joiner called Spilsbury, and PC Jones checked the body and declared the child quite dead. There were signs that the little girl had been beaten and

Station Road.

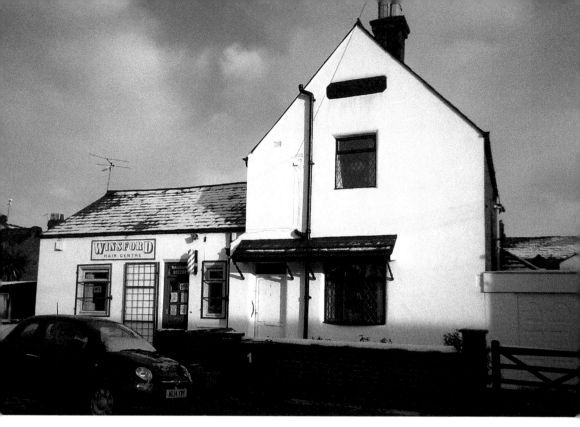

Wharton police station.

she had some string around the neck, although this was not the cause of death, which was more likely drowning. The small Wharton police station, now a barbershop, was besieged by crowds of furious locals and Phipps was taken to the main Over police station on the High Street, where he was charged with murder.

Dr Okell of Over examined the body and, among other things, found injuries that suggested the girl had been 'violently outraged' – in those days this was a discreet way of saying sexually assaulted. At the inquest the verdict was 'willful murder by James Phipps'. He was later committed for trial at Chester Assizes.

The Warburtons were poor people, and the neighbours and other friends and family provided the coffin, the gravestone, and the funeral cost. Thousands of people lined the route, and the curtains were closed on every house it passed. The inscription on the coffin read, 'There's a home for little children beyond the bright blue sky.' The service and burial were at Wharton Church, around 200 yards from the murder scene on what was known as the Claphatches, opposite the end of School Road.

Phipps was remanded to Knutsford Prison and tried at Chester Assize Court. He pleaded not guilty through insanity, but the jury took just seven minutes to find him guilty of murder. The judge assumed his black cap and delivered his

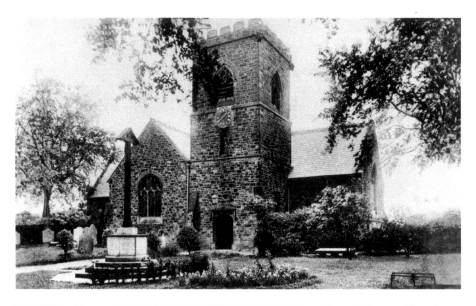

Above: Wharton Church.

Left: Eliza's grave.

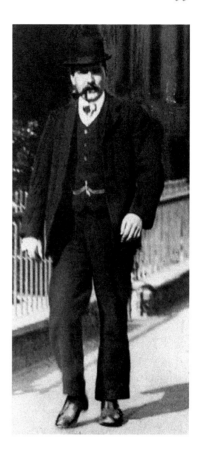

Henry Pierrepoint, executioner.

sentencing of death: 'You will be taken to a place of execution and that you be there hung by the neck until you are dead, and then your body will be taken down and buried within the precincts of the prison. And may the Lord have mercy on your soul.' He was returned to Knutsford Prison but resided in the condemned cell this time.

On 12 November 1908, he was executed at Knutsford Prison by Henry Pierrepoint, father of the more famous executioner Albert Pierrepoint. He was assisted by his brother Thomas.

THE HANKELOW MURDER

On Tuesday 18 April 1797, St Chad's Church, Wybunbury, was the location for the wedding of nineteen-year-old Edith Coomer, the daughter of a local farmer, to George Morrey.

The newlyweds settled in Nantwich, a town famous for making Cheshire cheeses. George opened a grocer's shop while Edith was kept busy having children and making cheese to sell at local markets. Over the next four years, the family made a comfortable living, and George's father had a farm at Hankelow, near Alsager. When he died in 1801 the family left Nantwich and moved to the village to take over the farm. George tended the farm and Edith continued as a cheesemaker. So far the relationship had been a good one. She had given birth to three boys and five girls, though one of the girls died in infancy.

A maid, Hannah Evans, and a twenty-year-old farmhand called John Lomas were employed on the farm. Edith was again pregnant, but had a miscarriage in February 1812. She was fifteen years older than young John Lomas, but their relationship commenced. The affair became serious and Edith wished dearly to make her relationship with John permanent. At the same time the last thing that

Nantwich.

Wybunbury Church.

she wanted was to lose her children, and a messy divorce would indeed cause this. There was only one thing for it: George would have to go for her to keep the farm, money, and children. She put the plan to murder George to her lover John Lomas, and this shocked and appalled him, but despite this they set it in motion. George went to the Witton Wakes (a major fair in Northwich) on 11 April 1812. Edith was still up at midnight when he returned, and the maid Hannah was with her. Food was prepared and they all partook of it before Edith and George went to bed. Hannah stayed up to clear away the table and went to her bed soon afterwards. The maid had hardly gone to sleep before a commotion within the house woke her up. She went for help before entering the bedroom of her master and mistress. She saw blood on the bed on entering the room, and George was plainly dead from extensive injuries. The police arrived, and the officer noticed that the farmworker John Lomas had blood on his clothes and, as a result, handcuffed him and set off to take him to the magistrate and police station for an interview.

When they got outside the house, and of his own accord, John Lomas stopped the officer and said he wanted to say what had happened and knew he would be hanged. His story was as follows. The murder of his master was the decision of his master's wife, Edith, and he agreed to go along with it. That night he and Edith had attacked George with an axe and beat him about the head until they thought he was dead. The attack was so brutal that they took out one of his eyes; they started to leave him when they realised he was still living. They resumed battering him until again they thought that he had breathed his last. But no, they had still not succeeded, and Edith pressed him to go and finish him off. He refused and said he could not resume the task and was firm in his refusal. Edith presented him

with a razor and told him to go and do as he was told. He had to cut George's throat, which he did under duress from Edith. She had pressed him to do the horrid deed because she wanted to marry him.

On hearing this confession, the officer took the handcuffs off, attaching him to the prisoner and handed him over to his assistant. In the meantime, he ran back to the house to arrest Edith. At the house, he told her that the servant had made a full admission, and she was to accompany him to the magistrate. On this, she covered her face with her apron and took a razor from her breast, drawing it across her throat, making a deep incision. Mr Bellis, the surgeon from Audlem, was in the house examining the deceased and he dealt with her wound by sewing it up.

Mr Faithfull Thomas was the coroner, and he held an inquest into the death of George Morrey. This took place on 14 April 1812. Lomas said that Edith had set him up to murder her husband. She would then prepare the way to kill him. On the day George came back from Northwich and went to bed, Edith came up to his room and told him that George was asleep and he must go down and kill him. He refused, and she went down the stairs, returning with an axe. She went downstairs again and he followed her, at which time she placed the axe in his hand. He told her they would be hanged, but she assured him that they would be alright and an intruder would be blamed. She indicated for him to go into the bedroom and held the candle as he struck his master three times with the axe.

He then heard the servant girl leave her room next to where they were. Edith wet her fingers and snubbed out the candle. Lomas started to run towards the door, and his master was shouting, 'Oh Lord.' His mistress told him he had not killed him and must go back and do it. It was dark and he hit out at his master three times, but thinks he only hit him once. As he ran out of the room, Edith was waiting for him with a razor, which she handed to him and made him go back and slit her husband's throat. When he went back into the room, his master was coming off the bed. He slashed at him twice, catching his chest, and when George went down to the floor, he pulled his head back and cut his throat twice. After this, many people arrived at the house and the policeman saw the bloodstains on his clothes.

Edith and John stood trial at Chester Assize Court before Chief Justice Robert Dallas on Friday 21 August 1812. Because the murdered person was the husband of one and master of the other, they were charged with 'petit treason' rather than murder, but it took the jury just a few minutes to find them both guilty. When invited to speak, John Lomas said that he deserved to die. Edith Morrey's lawyer declared that she was pregnant and could not be hanged immediately. The following Monday, John Lomas was hanged. Revd Fish gave him his last rites before being taken to the new city gaol and house of correction and hanged by the executioner, Samuel Burrows, with a large crowd looking on. Mr Burrows had executed fifty-three felons there during his twenty-four years in the job and died on 19 October 1835. Before death, Lomas made a speech urging the crowd

Chester Assize Court.

to learn from his mistake. After death, his body was taken to the infirmary next door to the gaol and dissected by Owen Titley.

Edith Morrey spent four months in gaol until her baby boy was born on 21 December 1812. She hoped that, with eight children to care for, she may be given a pardon. The horror of the murder ensured that this would never happen, and the following spring (1813) her baby was removed for adoption and she was executed by hanging. After that, her body was taken from Chester City Gaol to infirmary next door for an initial dissection by Owen Titley, who, as he had done to Lomas, removed the heart for preservation. Her remains were taken, followed by a huge crowd, to the Shire Hall where they would be thoroughly dissected in public. Her remains were left open for the public to file past and view the dissected corpse.

Addendum

Petit treason was an offence under common law in England in which a person killed or otherwise violated the authority of a social superior. In this case, Edith being George's wife and Lomas being George's servant.

SHEER EVILNESS CAN RUN IN THE FAMILY

As already stated, we do not intentionally report upon murders that have already been mentioned in other publications. But here we have a short introduction to a relevant story that has previously been reported upon due to its sheer infamy: the Priesty Fields Cannibalism in Congleton. During that murder in 1777, Samuel Thorley, who became known as the 'Congleton Cannibal', killed a ballad singer called Ann Smith. He was a butcher's assistant and after killing the girl he cut out her tongue, severed her head, and cut off her legs, arms, and thighs. What was left of her body was found floating in a nearby brook. Parts of her body had been cut off and taken away. Thorley later stated he wanted to know what

Leftwich.

human flesh tasted like and thought it would be like pork. To this end, he took a joint to his landlady and asked her to cook 'his pork joint'. She did so and served it up, making one of her tenants sick. Before the girl was found, he took part in the search. When the police visited the lodgings and recovered some of the meat, it was identified as human flesh, and Thorley was arrested. He was duly hanged and gibbeted for this most notorious murder.

The paternal great-nephew of the Congleton Cannibal, also called Samuel Thorley, may not have been a cannibal, but he was not a very nice person. Samuel Thorley the younger is the man we report upon here, albeit nearly thirty years later. He was born in Witton cum Twambrooks on 8 April 1804.

The year was 1833, and Samuel Thorley, who was aged twenty-nine, was courting twenty-one-year-old Mary Pemberton. Mary lived on a farm in Leftwich with her recently widowed mother. Thorley had asked her to marry him, and preparations for the wedding commenced. After a while, Mary's family noticed that nothing had been done. The house he promised to buy was not bought and the wedding arrangements had not commenced. Then came the worst discovery for the family. Although Thorley seemed to be an upstanding citizen with good prospects on the surface, it was discovered that he was nothing of the sort. He had several illegitimate children around the town with different mothers. On her mother's instructions, Mary ended the relationship with Thorley.

As a result Thorley turned to drink, spending his days in the pubs in Northwich. A short while later, when drunk, he met Mary at Northwich on the evening of market day. He insisted on coming home with her and took hold of her basket. Halfway to her house, which was about a mile away, they were met by her married sister, who took her arm and the two sisters left him.

Later that evening Thorley went to her house and knocked on the door. Mary let him in, thinking it was one of her brothers. The brother had not returned, and she was waiting up for him. When her brother did return Mary was sitting talking with Thorley and, not wishing to disturb them, her brother went straight to bed. Two or three times Mrs Pemberton shouted down to Mary, asking if she was coming up to bed. Mary shouted back that she would be up shortly.

A few minutes later Mrs Pemberton heard the front door slam. Again, she called Mary and received no reply, so she went downstairs. She found Mary dead, lying in the lobby covered in blood, as was the room, her head almost severed. It was only eight months since Mrs Pemberton's husband died and she was in a terrible state. Thorley went home and told his servant what he had done. He was covered in blood and changed his clothes, telling the boy to go and tell his father. He then set off to walk to Chester to give himself up. On arrival, his story was not believed, and he had to swear to it in front of a magistrate.

The inquest was held at the Bowling Green pub in Leftwich, and the jury declared that it was willful murder by Samuel Thorley. Mary's funeral took place at Davenham church, and a significant number of people attended.

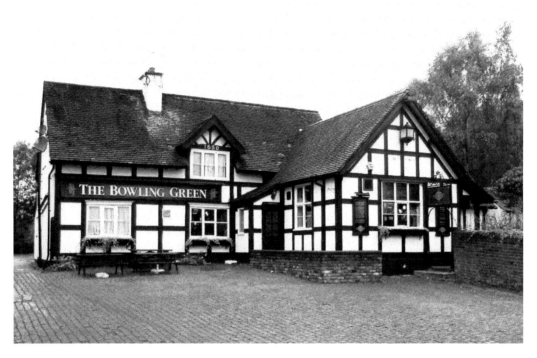

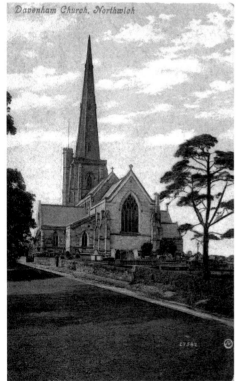

Above: Bowling Green pub, Northwich.

Left: Davenham parish church, containing the grave of Mary.

More people attended on 7 April 1834, after Thorley had been sentenced to death at Chester Assize Court. They had come to witness Samuel Thorley's hanging at Northgate Gaol. The hangman was Sammy Burrows, whose final duty it was before retiring. The crowd had travelled from Northwich and elsewhere to observe the death sentence. Thorley was reported to have been buried at St Helen's Church, Witton cum Twambrooks. Thorley would have been thirty the next day.

His great-uncle, also Samuel Thorley, was hung in Chester on 10 April 1777, and his body gibbeted in chains on the heath at Congleton, fifty-seven years before his great-nephew.

HOOLIGANISM IS NOT NEW

Today we are constantly getting new reports of wanton hooliganism – often when the pubs shut at night. We now turn to a tale of hooligan behaviour in Northwich from 1875.

The 1861 census has Mark Ledward working as a farm servant at the age of eleven with his brother James at the age of seventeen. They were living and working at White Hall in the village of Little Budworth in Cheshire.

Now to the evil deed. Since 5 January 1875, the Northwich police wanted Ledward on a charge of murdering James Derbyshire in Witton Street. After 11 p.m. young Derbyshire, under the influence of drink and accompanied by William and Thomas Hitchen, had just left the Crown Hotel in Crown Street. They set off towards his home in Market Street. As he reached the front of Mr Deakins' shop in Crown Street, he was jostled by a man and an altercation took place. The man drew a large dagger knife, which he waved about freely. Seeing the blade, Hitchen intervened and a fight ensued. The man backed out of Crown Street and into

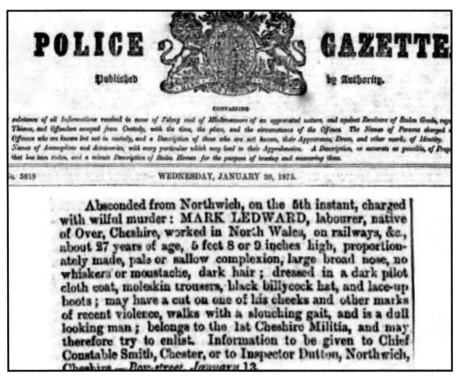

Copy of *Police Gazette*.

Witton Street, still waving the knife. He was seen to strike Derbyshire several times before walking off up Leicester Street. Derbyshire made to walk off but fell to the ground, having received two stabs in the body, one piercing the heart, causing him to expire almost immediately.

The police attended and witnesses soon ascertained that the assailant worked on a cinder barge on the River Weaver, and his name was Mark Ledward. He absconded the following day and was reported as wanted, and a wanted poster was circulated to nearby towns. A month or so later, the object of their search was in custody. He had travelled to Longport in Stoke on Trent to find work, but later he saw a policeman taking particular interest in him. Because of this he ran off and entered the Vine Inn near the railway station, but in his haste to check the train times he left his coat behind. The landlady recognised it from the wanted posters for the murderer circulated. The police were called and soon apprehended Ledward. The following day he was conveyed to Northwich.

Ledward appeared at Chester Assizes, where he was indicted with the murder of James Derbyshire. The inquest that had been delayed upon Derbyshire took place in the Northwich Drill Hall, and a verdict of manslaughter was returned upon Mark Ledward. Afterwards, magistrates committed him for trial on a charge of willful murder. The grand jury threw out the bill that was preferred for murder and lowered the charge to manslaughter. Mr J. H.

The Crown Hotel.

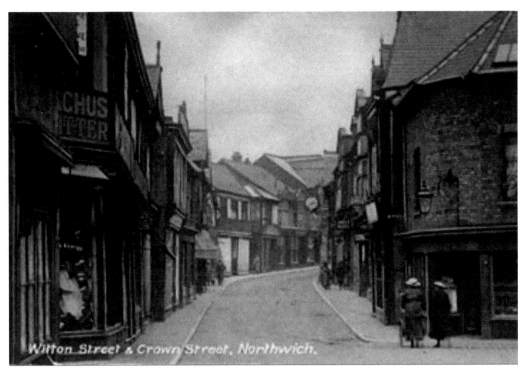

Witton Street (from Crown Street), Northwich.

Cooke, the solicitor of Winsford, instructed the barristers and the opening address suggested that the actual crime was very close to being murder instead of manslaughter. The trial was long and detailed. It uncovered that during the 'melee', William Hitchen, a soldier in uniform, handed his belt to his brother Tom and, with the belt in his hand and a coat around his arm for protection, he fended Ledward off. He struck Ledward several times as the latter was backed into Witton Street.

Interestingly, at nearly midnight a flock of sheep came down Witton Street from the station driven by Richard Stubbs, and they passed between the assailants, making Stubbs a witness to the fight. He saw Derbyshire, who was very drunk, 'chuck' Ledward under the chin. Another witness was Arthur Dutton, son of Police Inspector Dutton of Northwich.

At the end of the long case, the jury returned a verdict of guilty of manslaughter, but they considered that there had been a great provocation. The judge sentenced Ledward to ten years' penal servitude. This sentence commenced in April 1875, and by 1891 he was a free man and worked as a salt labourer. He was married to Martha Ledward with two sons William Hodkinson (stepson), Levi Ledward and daughter Beatrice Ledward. By 1911 they lived at No. 536 Victoria Terrace, Over Lane (Winsford High Street).

Victoria Terrace being demolished in 1965.

A CREWE AUNT MURDERER

Mrs Sarah Griffiths was a married lady and aged fifty-nine. She lived at No. 37 Henry Street, Church Coppenhall, now Crewe, almost adjoining the Methodist Chapel. She lived with her sixty-nine-year-old husband, who worked at Crewe Locomotive Works. She was the aunt of Thomas Henry Bevan, aged twenty, described as a fitter. Bevan lived near his aunt and would frequently visit her. On 26 March 1887, he was paying a visit; his half-sister Mary Jones (aged nine), who lived at the house, was also present. When he came in she left to go to the Co-op store in Market Street, leaving Bevan and his aunt alone in the kitchen. The milkman, Mr Fearn, called with his bill and Mrs Griffiths went to a drawer in the room and took out her purse. Bevan saw her take a pound note from it and hand it to Mr Fearn, receiving change in return, which she replaced in the purse and put the purse back in the drawer.

Bevan decided to murder his aunt and steal the purse, which he did most violently and evilly. He hit his aunt with a big dolly peg, which broke, and then he kicked her until he thought she was dead. She was not. So he next tried to strangle her as she lay on the floor, then jumped upon her body until he was sure that she was dead. Having, as he thought, committed the murder, the main

Crewe town centre, 1950s.

witness would be Mary when she returned, so he decided to wait for her return. He lay in wait and met her at the back door. She saw her aunt's body lying on the floor when suddenly she was grabbed by Bevan, who tried to strangle her by twisting her neck around. He knocked her to the floor and took up the fire tongs, violently striking her with them several times, which broke her skull in two places. Believing her to be dead, he returned to his aunt and saw that she was still breathing. He jumped on her body again to make sure this time that she had died, took the purse from the drawer and then left the house.

Mr Henry Griffiths finished work at noon and returned to the house. He saw the broken dolly peg on the floor and his wife's body; he felt her head but found it to be cold. There was no sign of the little girl at first as she was hidden by clothing, but suddenly she stumbled to her feet, saw him and said, 'Oh uncle, uncle, uncle,' and fell back to the floor. When later checked by the doctor it was found that Mrs Griffiths had every rib broken, some completely separated – consistent with someone jumping on her prone body. Mary Jones had severe head and body injuries, with seventeen wounds about the head and body that would be life-changing; however, although in extreme pain, she did not die and was able to give evidence at the trial. On Wednesday 30 April 1887, the funeral of Mrs Griffiths was held. The procession started the journey from Henry Street to the church a mile away, and the route was lined with people paying tribute to the

The chapel and No. 37 Henry Street.

deceased. Her house was next door to the Primitive Methodist chapel and many of the congregation were in the procession. The body was taken into the parish church at Coppenhall, where Revd W. C. Reid conducted the first part of the service. The second part was at the graveside. Thousands of people were present and it was controlled by the police. Her elderly husband had to be physically supported as the coffin was lowered.

Thomas Henry Bevan was, from a young age, in trouble in one form or another. He spent five years in a reformatory, but this had no beneficial effect on his life or prospects. Since the reformatory he had lived with another aunt, Mrs Clutton, the sister of the murdered woman. They resided in Orchard Street, Hightown, Crewe. He stole from his relatives twice, but after reporting the matter to the police they declined to prosecute.

He was arrested after committing the most heinous crime of murdering his aunt and attempting to murder his little half-sister. At the time of arrest he displayed the utmost callousness. Awaiting trial at Knutsford Gaol, his priority was to ask what sort of fare condemned persons could have between sentencing and the death penalty. He was told that he could have anything he liked. He said that he would make the authorities keep him well between those times. As it turned out he never did this, accepting the usual prison food. He also made a full admission to the prison governor, including the location of his aunt's purse, which he had thrown into a bush. Deputy Governor Mr Taylor and the prison

Coppenhall Church, Crewe.

James Berry, executioner.

chaplain went to Crewe and, following his directions, found the purse, which still contained 17s 6d.

The prisoner was twenty years old and weighed 8 stone 9 pounds. He was well prepared for the sentence that the judge would impose: he was to be hanged. On completion of the trial, he was returned to Knutsford Gaol to await the hangman, who was to be ex-policeman Mr Berry. The prisoner walked to the scaffold quietly, never uttering a word. The noose was adjusted and the bolt drawn. He died instantaneously without a struggle.

15

WIFE ABUSE LEADS TO MURDER

The following story comes from the 1800s. Today there is much criticism of light sentencing at courts, but the eighteenth and nineteenth centuries had the same problems. In fact, there was even more bizarre sentencing. In those days, using a forged pound note or stealing a horse could – and probably would – receive the death sentence. And for stealing some bread you'd recieve a one-way trip to one of the developing countries. The offence of manslaughter, however, was somewhat different. For this you' receive a 10s fine and two years' hard labour. It was all extraordinary.

Our story centres on the castle area of Northwich, at the top of Castle Hill in 1843. A widowed and remarried woman, Sarah Hough, had just given birth and was suckling her baby. She had three children from her previous marriage and this baby was with her new husband William Hough, the captain of a flat that sailed the river to and from Liverpool; Hough also had four children of his own. Sarah had a small shop on Castle Hill. On the night in question, Sunday

Castle Street, Northwich.

2 April 1843, Sarah and her daughter Catherine Allcock were in the house; her husband William Hough had been away on the river for a week and was due to return home that morning at around 6 a.m.

He came into the house and sat down for a while. He had been drinking heavily, and half an hour later he left the house again. At 10 a.m. he returned from the Wheatsheaf, now very drunk, and lay down on the squab. By then another sister, Nancy, had joined Catherine and they both witnessed what happened next. After a while one of William's sons, Thomas, came in and complained to his father that he had not been getting sufficient food from his stepmother, Sarah, while he was away. Before returning and locking the door William took two pans of dumplings and potatoes off the fire and placed them in the backyard. He rolled up his sleeves and clenched his fist. Sarah stood up, still holding the baby, and picked up the poker but did nothing with it. She told him that she would not desert her children for anyone, at which point he put his fist in her face and asked her where she wanted it. She replied 'anywhere'. He then punched her hard on the breast, hitting the baby. Catherine took the baby from her, and before she left the room she saw her stepfather punch her mother again hard, push her back onto the sofa and kneel on her to hold her down while continuing to strike her in the head and body. When she got away, Sarah ran into the yard and shouted 'murder'.

The Wheatsheaf Hotel, Castle Street, Northwich.

William followed and punched her hard in the back of her head twice, which knocked her to the ground. William started to hit Catherine while neighbours came and helped Sarah to escape to the home of Mr and Mrs Marsh. She remained there until the Hartford constable arrived.

A neighbour, Catherine Leather, told the constable that she had gone into the yard and Sarah was standing there and shouted to her, 'Oh woman, will you stand to see me murdered?' She then saw William punch her twice in the head and shouted to him, 'Oh, William Hough, don't beat her.' He replied, 'I'll knock her bloody neck out.'

Sarah was very ill at Mrs Marsh's house and stayed there all night. The following morning Dr James Dean attended to treat Sarah, but there was not much he could do – she was not at all well. He next saw her on Wednesday 5 April and found her to be near death. He ordered her to be bled and prescribed some tablets, but she died the following day. The next Friday he performed a post-mortem with two other doctors, and an inquest was ordered by James Rosco, the coroner for Knutsford. The jury's verdict was that she had died of natural causes from a visitation of God and her body was released for burial. On the following Sunday – 9 April – she was buried at Witton Cemetery, at which

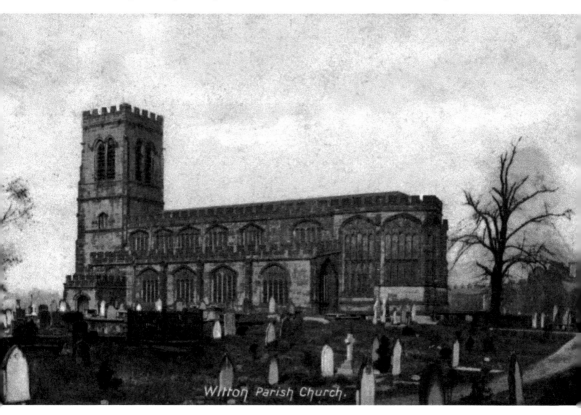

Witton Church.

time the police were called to restrain the inflamed crowd of mourners who believed that the verdict was not correct. William Hough was there in his best suit and was berated and booed by the crowd, who tried to get at him. He was jostled as he left the church. After the burial many rumours circulated about the real reason for Sarah's death.

It was then discovered that the inquest under Mr Rosco was irregular: Castle was not in the Knutsford division. The coroner for Northwich, Mr Henry Churton, ordered that the body be exhumed and given a second post-mortem, and this was carried out. It took ten hours and the result this time was that death was caused by the injuries to Sarah's brain caused by her husband, William Hough. The coroner ordered him to be taken to the gaol at Chester Castle to await the next assizes on a charge of manslaughter. In August, the trial was held at Chester Assize Court, with the attorney general being the lead prosecutor. A charge of murdering his wife was put before the jury, but the defence suggested it was the wrong charge and it should instead be manslaughter. In his summing up the judge allowed the jury to find for murder or manslaughter. They retired for five minutes and returned with a finding of manslaughter. The judge gave a sentence of two years in prison. In 1863, William Hough was back living on Castle Hill.

THE MURDER OF A GAMEKEEPER

Thomas Chesters was a farm labourer at Mr Sheen's farm at Tilstone Fearnall, near Tarporley. On the morning of Friday 17 April 1857 he was walking to work across the farm fields when he came across a body. It was lying near a small wood and he recognised it as that of John Bebbington, the gamekeeper. He immediately went and called for Mr Sheen, who accompanied him back to the body with two of the farmhands. John Sheen found the body with the feet in a ditch and the body in the field. He saw that his shotgun lay beside him and, on checking it, it was found to be loaded. He first went to the landowner, Mr Corbett, at the lodge and then back to the body. On turning the body over, he saw that there was a hole in the back of his coat; up to then, it had not been in view as the body lay on its back. PC Kearns, the local police officer, was taken to the scene by Chesters and found marks where someone had walked through a field of wheat. The officer

Tilstone Lodge gateway.

also took possession of a boot, later found to be that of the deceased. Several footprints were clearly visible in the soft soil.

Superintendent Francis McDermot of the Eddisbury Police Division attended the scene and tracked the footprints across a few fields until they reached Sandy Lane. He found a very distinct impression of two people walking together and one not so distinct. A short distance away was the home of John Blagg, a known poacher. Blagg's boots were seized at his house and found to perfectly match the footprint at the scene of the crime and by the gate into the lane.

The investigation got underway, and it came to light that in the past Bebbington had accosted Blagg while he was poaching, and Blagg's shotgun had been seized. Others heard Blagg say in Beeston that he would get his own back and 'do for' Bebbington on one of these days. He was, however, drunk at the time. Then there were the cartridges used to murder Bebbington; they were the same Ely make as those purchased a few days before by Blagg. The evidence against him was stacking up, albeit circumstantial. James Jones, an associate of Blagg, was suspected of the crime, but the evidence against him was thin. Unlike the circumstantial evidence so far amassed against Blagg. The superintendent put Blagg into the constable's custody and continued with his enquiries. He seized

The estimated murder scene.

Blagg's shotgun from under the bed and examined the cartridge wads used by him. The prisoner made no objections. From his arrest to the end of his days, he was insistent that he had not murdered John Bebbington. He was remanded to Chester Castle Gaol to await his trial at the assizes, and throughout his incarceration he was questioned repeatedly by various people. All urged him to tell the truth, including his wife, but he was insistent that he already was.

He told his cousin, Mr W. Blagg, when he visited him in prison that he would rather be hanged than sent away to another country. He also said, 'Bill, I am as innocent as thou art, and I could tell thee something, but I will take it with me.' He also said that he knew who the real murderer was but that he would die before he would confess. When he appeared at Chester Assizes he was duly found guilty of murder, for which there was only one sentence – he was to be hanged. A petition was started asking the Home Secretary, Sir G. Grey, to show mercy and allow a commutation of the extreme sentence. This was refused.

On Friday morning, 28 August 1857, he was visited in his cell at Chester Castle Gaol by the governor (Mr Dunston), the chaplain and others who remained with him as the executioner (Mr Calcraft) pinioned him. The bell then started to toll as the mournful procession proceeded to the scaffold. On the way the chaplains begged him to confess to the murder, but he refused, saying he knew who did it but would not tell. A crowd of around 5,000 people had gathered to watch the

Tilstone Church.

John Bebbington's grave.

hanging at the castle's front. Preparations were completed, the rope was adjusted, and the bolt was withdrawn. The drop, however, did not happen immediately as the bolt was stuck. Mr Calcraft kicked the lever to release it and Blagg cried out, 'O'Lord! O'Lord!'

But that was not the end of this sad tale. Thirty-three years later, in 1890, a man in the USA confessed to the murder. His story did not exactly fit the crime as he had John Blagg living in a hut in Delamere Forest where he made brushes. But the publicity gained caused a lot of interest, especially in Cheshire and among the people who remembered the murder and the hanging of John Blagg, who never admitted it but knew who it was.

Two years later, because of the strange admissions by the unknown man in the USA to the rector of St Paul's Church in New Orleans, Mrs Blagg was visited by a journalist. When interviewed she stated that Blagg's friend, James Jones, had come to their cottage on the night of the murder and asked to borrow John's boots. Mrs Blagg was never comfortable with Jones and the boot marks were an intrinsic piece of evidence, together with the fact that Blagg's gun had shot the gamekeeper.

Mr Calcraft, executioner.

By then, Jones was living in the Chell Workhouse in north Staffordshire. When the murder was mentioned he became uncommunicative and refused to talk; however, the evidence points at him as the person who wore Blagg's boots and used Blagg's gun to shoot the gamekeeper. It was commonly suspected that Blagg had been innocent of the murder, and Jones was almost certainly the guilty man.

And there the story ends. Whatever reason Blagg had to keep what he knew to himself is baffling. It was tempered though by his admission he was innocent of the murder. But not of being a poacher – a crime that carried transportation, which he did not want. It is possible the crime was poorly investigated as Blagg was not a particularly honest man. James Jones took what he knew to the grave, carrying with him a very strong suspicion that he had allowed his friend to face the death penalty on his behalf.

Chell Workhouse, north Staffordshire.

17

OUTRAGE IN OVER

Kathleen Muriel Oakes was the daughter of Harry Oakes and resided with her parents at Pool Head Farm, Darnhall. She had been apprenticed to dressmaker Mrs Maddocks in High Street, Winsford, and on leaving each day she would cycle home. On Monday 12 January 1914, she had left work at around 8 p.m. and set off for home. She cycled down Woodford Lane, Hebden Lane and into Oakes's Lane.

Oakes's Lane was a continuation of Blakeden Lane and was probably named after the Oakes's of Pool Head Farm, where Kathleen lived. One of the fields between there and the farm was known as Whitney's field, and when she reached it she saw the defendant, John William Prince, walking towards her along the narrow cinder path. She rang the bell on her bike, but he did not get out of the way.

As he drew level with her, he hit her with an iron bar on the head, and she fell from her bike. He fell on top of her, but she managed to get up and run off. She

Scene of the initial assault at what was formerly known as Oakes's Lane.

screamed as Prince ran after her then tripped and fell, giving him time to catch up. He grabbed her around the waist and pulled her up, dragging her to a pit in the field. She asked where he was taking her, and he told her that he was taking her home. She pleaded with him, offering him her watch and bike, but he said he didn't want it. She noticed that he still had the iron bar in his hand, so she grabbed hold of it. He warned her that he would kick her to death if she didn't let go. He pulled the bar away from her and hit her with it again.

He threatened to leave her there to die but started to tear off her clothing and attempted to assault her. He threw her to the ground, and she noticed that her head was bleeding badly. Prince hit her about the head again with the iron bar that was later found to be a heavy crowbar. She struggled free and escaped through a fence, running off and carrying the clothes he had torn off her. She met William Stanley, who took her home where she arrived covered in blood. Dr Okell was called to treat her and he found many injuries to her head and other injuries to her arms and body, including broken fingers. John William Prince was arrested the following day, having been found hiding in a hayloft. When apprehended by PC McMorine, he said, 'It's alright, my mind was a complete blank; I hope you will hang me tomorrow.'

The Wheatsheaf.

Woodford Lane, home of John William Prince.

Prince, a farm labourer aged thirty, had lived with his sister, Catherine Dunning, and her family at No. 85 Woodford Lane, Over. On the day of the offence he had been drinking in the George and Dragon and the Wheatsheaf in Delamere Street.

Prince was sent to Knutsford Gaol to await court. When his actions became known, there was much interest. It started on the way back from Knutsford where he was to be placed before the Court for Committal Proceedings. There was a change of trains at Cuddington, where many people had gathered. He was then taken off at Whitegate station and continued the journey from there in a sealed car. Again, a big crowd had gathered at Winsford Court. There were six magistrates and the chief constable on the bench, and the deputy chief constable was at the solicitor's table. Because of the delicate nature of her evidence, the court was cleared when Kathleen Oakes entered the box. Prince was committed to Chester Assize Court for trial on offences of attempted murder and attempting to 'ravish' Kathleen Muriel Oakes.

At Chester Assize Court on 27 February 1914, he was convicted of attempted murder and the offence of attempted 'ravishing' was not proceeded with, but it was to remain on file. The judge sentenced him to fifteen years of penal servitude, adding that he would also have liked to sentence him to be whipped for such a heinous crime. Mr Justice Avory said, 'But in my opinion, such a man who can resort to such violence with such a weapon for the purpose of gratifying a momentary and filthy lust is not safe to be at large at all events 'til

Above: Winsford
police station and
court.

Right: Kathleen Muriel
Oakes attending court.

such a time as all such ideas have passed away from him.' The definition in law: 'Ravishment is the same as rape, a criminal offence defined by most statutes as unlawful sexual intercourse with a female by a male with force and without her consent.'

In 1939, John William Prince resided in the workhouse on London Road, Northwich, where he died in 1941 at the age of fifty-seven. Kathleen Muriel Oakes married in 1925 and had a son. She passed away in 1974 at the age of seventy-six.

Northwich Workhouse.

A HEINOUS MURDER IN HYDE

For a small town, Hyde has undoubtedly had its fair share of murders. To name just a few better-known ones, we have the Moors murderers, Myra Hindley and Ian Brady; then Harold Shipman, who killed at least 218 patients from 1975 to 1998; Dale Cregan, who in 2012 made a hoax phone call and murdered PCs Nicola Hughes and Fiona Bone; and Frieda Hunter, aged twenty, and Joe Gallagher, aged thirty, were battered to death in their bed in Hallbottom Street, Hyde, in February 1979 – the offender is yet to be found. We will cover another heinous crime in Hyde many years earlier in the following story.

Ivy Lydia Wood was twelve years old and the younger daughter of John Wood, a hairdresser of Newton Street, Flowery Field, Hyde. John served with the Royal Engineers in France and had been demobbed at the end of the First World War, having been wounded in action at Bullecourt.

Ivy Lydia Wood.

Ivy was a bright, intelligent girl. She attended Flowery Fields Sunday School and was described as one of the best dancers. At Christmas 1918 she had distinguished herself as Peggy in the play *Jack and the Giant Killer*. She was also described as good looking with an amiable disposition and a very competent swimmer and fine singer. Shortly after 6 p.m. on 25 July 1919, Ivy went on an errand for her father to another hairdresser just 200 or 300 yards from her home. When she did not return, her father closed the shop and went looking for her and to inform the police. A search was made along the nearby canal bank and other parts of the town. It was not until around 1 a.m. the following day that her dead body was found lying in the yard of a cotton factory a few hundred yards from her home. The mill nightwatchman had made the discovery.

The body was in a terrible state, and she appeared to have been the victim of a shocking murder. The body was bruised and disfigured, her head and face swollen, and her clothes were torn and soiled. The body was taken to the town mortuary where a post-mortem took place. It revealed that the girl had been brutally attacked and murdered; her body bore marks of terrible violence. In the meantime, the police searched for the murderer. The search started with Arthur Beard, the man who found the body in the secluded yard of Messers Ashton Brothers & Company's Carrfield Mill. He was arrested on suspicion of the murder. Beard had been on the premises when Ivy walked past on her return from the errand. A boy named Gosling saw her standing at the railings of the factory near the watchman's lodge on Friday evening at around 6.30 p.m. Very shortly afterwards she had disappeared.

Arthur Beard.

The chief constable of Hyde, Mr Danby, and Inspector Shaw took Beard to where he said he had found the body. The chief constable found his story inconsistent, and he remained in custody. Later that morning, Arthur Beard, aged thirty-three, was placed in the dock at the police court on the charge of murdering Ivy Lydia Wood. There was a full bench of magistrates chaired by Alderman W. J. Sherry. The court was packed and there was a large crowd outside. Beard had relatives in court and Mr H. Bostock, a solicitor, represented him. Chief-Inspector Arthur Neal, a CID officer from Scotland Yard, was the first to give evidence. He said he started to interview Beard and told him that he had read his statement and inspected the girl's clothing. Shortly after, he was called away to speak with the chief constable, leaving his fellow Scotland Yard detective, Sergeant Everligh, with the prisoner. Minutes later he was called back into the interview room, and the sergeant said to him, 'Mr Beard says he cannot keep it on his mind any longer, and he wants to speak with you.' Beard said to the chief inspector, 'I want to tell you the truth.' He was advised that anything he said would be written down and would be given in evidence. Beard agreed, saying he had to get it off his mind, and the sergeant took down a written statement at his dictation. Afterwards, he was charged with the murder of Ivy Wood, to which he replied, 'Yes, I shall be better now.' Beard was remanded in custody.

It came out that Ivy was passing Carrfield Mill and for some reason entered the yard. The prisoner saw her and took her into the pump room where the murder and outrage took place. Shortly afterwards, leaving the body hidden, Beard went with a man called Jones to the Navigation Hotel (now Cheshire Ring) in Manchester Road, Hyde.

Beard came from Chapel Street, Hyde, and was in the Royal Marines during the recent war. He had been demobbed three months ago and had been the watchman at the mill for seven weeks. In the interview with Chief-Inspector Neal, he said that the girl walked into the yard and he asked her what she wanted. She replied that she was having a look around, so he offered to take her. They went into the fire hold and he asked her to kiss him, so she tried to run away towards the lodge. He said he had a bit of a struggle with her and lost control of himself, and she seemed to go unconscious. He said he left her on the ground and went to meet Jones to go to the public house where he was elected a member of the Enginemen's and Firemen's Union. He said he should not have hurt the girl, but the drink caused it and the whisky added the final touch. The jury returned a verdict of willful murder, and he was committed to Chester Assizes for trial and remanded to Strangeways Prison in Manchester.

At the inquest, Dr Smith said he had examined the girl's body and found evidence of violation (sexual assault/rape). Wounds to her body proved that she had unquestionably been 'ravished' (raped). The girl's head was severely bruised and her hands were clenched. Death was due to suffocation and violation. Beard's trousers were very soiled. The inquest ended when Mr Wood, the girl's father, broke down and wept bitterly.

The burial of Ivy Wood probably attracted greater or more painful interest than any in the history of Hyde to date. The coffin was carried on an open landau from her home to Hyde cemetery. The casket was covered entirely in flowers and the road was lined for the entire mile and a quarter to the graveyard. The locals collected money to build a permanent memorial on her grave, which remains there today.

The funeral cortege in 1919.

Hyde Cemetery.

On the 100th anniversary of her death – 25 July 2019 – another large gathering attended a service to remember the little girl who had been so brutally murdered all those years ago. The grave and monument were beautifully prepared for the commemoration.

But back to the evil creature responsible for this cruel attack and murder. He appeared at Chester Assize Court for trial and was found guilty of murdering Ivy. The judge sentenced him to death – what a pity this was not the end of the story. After the sentencing, the judge lectured the crowd on the evils of drink, using Beard as an example. A week later, a petition was sent to the Home Secretary for Beard, an ex-Marine, and a further petition was started in the War Comrades Club in Hyde.

As a result, the Court of Appeal agreed to hear the appeal of Arthur Beard. It was stated that Beard had been in the Royal Marines for around twelve years and had served in the Far East and France, where he was gassed. He also spoke of him having what was then known as 'shell-shock' but would be better known today as PTSD.

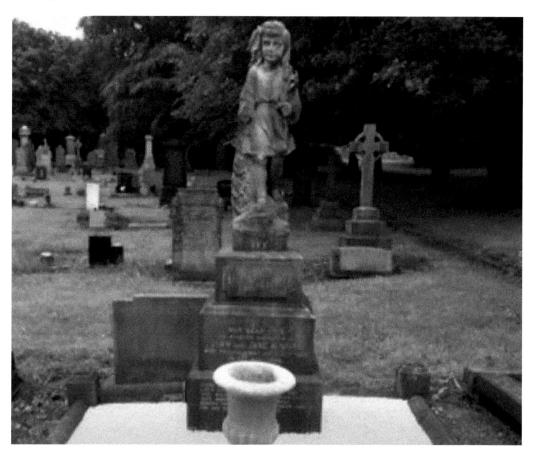

Above and overleaf: Ivy Lydia Wood's grave.

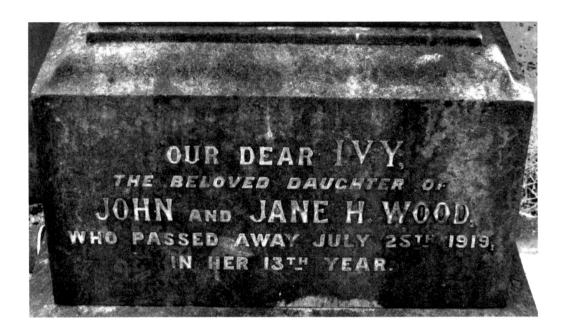

At the time Beard was in Walton Gaol in Liverpool and arrangements were made to take him to London for the appeal. In the meantime, the petition was still attracting signatures and had 10,000 to 11,000 names already.

The appeal against the death sentence was allowed and the offence was altered to manslaughter. Once again, the fact that he was drunk was highlighted. He received a sentence of twenty years' penal servitude.

The Crown appealed against the findings of the Appeal Court. This was the first murder appeal to be heard in the House of Lords, and accordingly an unusual number of Law Lords attended. The argument was to decide if being drunk could be a defence for murder. The Lord Chancellor advised the king that the capital sentence should not in any way be carried out in the circumstances.

The Lords' decision reversed the Appeal Courts ruling and restored the original murder conviction. When Beard committed the rape, it could not be proven he was so drunk as not to know what he was doing. A truly heinous crime had been committed against an innocent young girl. A self-confessed murderer was allowed to escape the hangman in exchange for twenty-two years' penal service.

YOU CAN'T ESCAPE THE HANGMAN

For many years Chester Races have drawn crowds of gamblers and people wanting a pleasant day out, but news broke of a terrible incident on Saturday 9 May 1801 involving people on their way to meet the hangman. These men were Samuel Johnson and John Morgan (for uttering forged banknotes) and John Clare (for housebreaking).

Clare, Johnson (alias Thompson) and Morgan were sentenced to hanging and were to be executed on 9 May 1801. Johnson and Morgan accepted their fate and caused no stir while awaiting the fateful day. Clare, however, did not. He constantly declared that he was not born to be hanged. Because of this he was carefully watched at the castle to ensure he did nothing to destroy himself. Each day he asked one of the turnkeys to check the post to see if a reprieve had arrived for him, but this was not to be. However, he still asserted that he was not to be hanged.

On the day of the executions the three were loaded onto a cart for their final journey, and the cart set off through the city from the castle prison to the hanging

Painting of the Hanging Tree at Boughton.

tree at Boughton. They had nearly arrived at the gallows when Clare dived out of the cart. He ran through the watching crowd, arriving at the slope upon which the gallows stood. He ran and rolled down the bank and into the river. He was pulled from the water within a few minutes, but he was dead. It could not end there, however. His body was carried to the hanging tree where it was suspended with the other two for the usual time. So, despite his actions, his body was carried to the gallows and hanged as decreed by the court. He had not escaped the hangman.

ACKNOWLEDGEMENTS

The authors would like to thank the many people who have answered queries and allowed access to the photographs, including Bob Curzon and Revd Alison Fulford. Most of the old pictures come from period newspapers and the newer ones were taken by the authors.

ABOUT THE AUTHORS

Rose and Paul Hurley are married. Rose undertakes the research and Paul constructs the stories. Rose was a Senior Project Manager in IT until early retirement, and Paul has been a writer since retiring from the police in 2002. He has written twenty-eight history books covering Cheshire and four books on the history of the railways. He has a weekly column in the local paper and has contributed to several magazines. He has written an award-winning novel and a successful police autobiography.